Horned Lizards

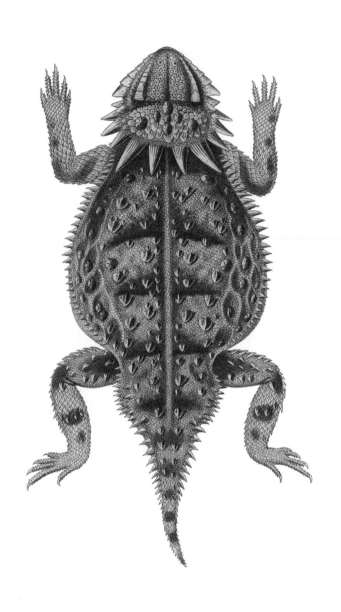

Horned Lizards

JANE MANASTER

Wendy L. Hodges, Scientific Advisor

Texas Tech University Press

"The Horned Toad's Song" from Aileen O'Bryan, "The Diné: Origin Myths
of the Navajo Indians," *Bureau of American Ethnology Bulletin* 163 (1956),
reprinted by permission of the Smithsonian Institution.

"The little red spiders" and "A little grey horned toad" from Ruth Murray
Underhill, *Singing for Power: The Song Magic of the Papago Indians of
Southern Arizona*. Copyright © 1938, 1966 by Ruth Murray Underhill.
Reprinted by permission of the University of California Press.

Printed in the United States of America

Library of Congress Cataloging-in-Publication Data
Manaster, Jane.
Horned lizards / Jane Manaster
 p. cm.
 Originally published: Austin : University of Texas Press, 1997.
 ISBN 0-89672-495-6 (pbk. : alk. paper)
 1. Horned toads. I. Title.

QL666.L267 M25 2002
597.95—dc21

 2002032366

02 03 04 05 06 07 08 09 10 / 9 8 7 6 5 4 3 2 1

Texas Tech University Press
Box 41037
Lubbock, Texas 79409-1037 USA
1.800.832.4042
ttup@ttu.edu
www.ttup.ttu.edu

For Kim, Rex, and Dawn

Contents

Color section follows page 52

Acknowledgments

*M*any people contributed to this small book. My special thanks to Eric Pianka, for his patient and never condescending instruction; to Wendy Hodges, for her helpful recommendations on scientific matters; to Bertrand Baur, Jim Corgan, and Brian Compton for following regional trails that defeated even the almost omnipotent computer; to members of the Horned Lizard Conservation Society, particularly Lester Milroy, who supplied several of the charming color pictures, and Carolyn Todd and Lee Stone, who welcomed me to their ranks; and to Bill Howell, editor of the *Coalinga Record*, who tracked down a favorite photograph. Above all, thanks to Guy, my husband, who did his darndest to share my enthusiasm for horned lizards.

Horned Lizards

Introduction

The world is silent, and the Texas sky in the Big Bend is tinted the pale blue of daybreak. The animals of the night have disappeared into their lairs. As if wary of the heat that will come all too soon, the land seems empty of life. Nothing moves. Cacti and shrubs, water reeds and conifers don't allow the wind to murmur through their leaves. And yet there is an awareness of space shared, a sense of not being alone. The presence is not menacing, not a bear that has wandered up from Mexico, nor a cougar eager to repopulate its kind in the park, and no bird wings upward to the cloudless sky.

Where there was only a suspicion a moment ago, now a head is emerging, the head of a reptilian sun worshipper. The eyes blink, a small body shrugs up through the sand and sits on two forefeet. Then again there is stillness. The horned lizard waits until the sun heats and energizes it enough to go about the day's business.

The horned lizard is surprisingly charismatic. It is a homely creature, with the scaly, fierce appearance of a latter-day dinosaur or legendary monster. But the fearsome look belies a gentle, even timid disposition that has long fostered a mystique in North American folklore. Some two to six inches in length, with short, potentially lethal horns and coloration that provides exemplary camouflage, the horned lizards are seen less and less frequently in the wild. They were more familiar when they enjoyed the limelight as curios and as a commodity for the young entrepreneurs who sold them for a nickel or so apiece to dealers and pet store owners. Such profitable ventures received the kiss of death a generation ago when conservationists recognized early steps on the path to extinction.

Although they are popularly known as horny toads, the term "horned lizard" is more accurate. The scientific name, *Phrynosoma*, was formed from two Greek words, *phry*, "toad," and *soma*, "body," by the German scientist Arend Wiegmann, who christened the genus in a paper published in 1828.

Long before they began to intrigue scientists, the lizards held their place in Southwest American Indian culture, represented on the extraordinarily beautiful pottery of the Mimbres and Anasazi peoples and their descendants. The familiar silhouette graced bowls and ritual objects fashioned in clay and stone and was woven into tribal mythology and superstition.

When Spain's King Philip IV sent expeditions across the Atlantic Ocean to his growing empire in the early seventeenth century, he demanded an inventory of the flora and fauna of Mexico and lands beyond. He was not disappointed with the wondrous accounts and examples of vegetation and animal life that were carried back to Europe. Among the innumerable exotic plants and beasts, the humble horned lizard lent itself to fanciful description.

Two hundred years elapsed before conclusive sightings of horned lizards farther north were reported in the English language, but once they were spotted, curious adventurers found them fascinating. During the nineteenth century, travelers, surveyors, then scientists told their tales. The lizard was removed far from the desert lands of the Southwest where, as one biologist explained, it could "take refuge beneath the formidable spines of the Agaves and Yuccas, and the prickles of the Opuntias." Even when preserved after death it was considered fascinating. One enraptured scientist laboring in his California laboratory got quite carried away with the task in hand, solemnly reporting that the material on which his study was based "consists of a good working collection of some sixty alcoholic specimens."

Today, field studies are assisted by technological advances. Often each individual lizard that unwittingly participates in a research project can be tracked as it putters around wearing a minuscule backpack holding a tiny radio transmitter, in much the same way that criminals are monitored.

Horned lizards have been introduced in states along the southeastern seaboard, and in lands beyond American shores, kept alive by luck and prayers until an understanding of their needs can be achieved. Annual proceedings from scholarly European institutions have mentioned the lizard time and again, musing on its extraordinary appearance and characteristics. Occasionally the lizards have been set to work. Legend suggests they were considered likely predators for insect pests in Hawaii and Bogotá a hundred years ago. Taxidermists did their best to revitalize the creatures for exhibition purposes and to accommodate souvenir hunters, especially in southern California. After World War II, children in several European countries bought them with their Saturday allowances, at a time when family budgets did not run to the cost of pet food.

The native range of all thirteen species of *Phrynosoma* is restricted to North America, reaching from the southern fringe of Canada down through Mexico, with one species crossing over the border into Guatemala. Of the thirteen species, seven reside in the United States, and throughout the native range a number of subspecies may be added. Habitats vary from extremely hot and arid to colder, damper areas, but the horned lizard is primarily a creature of warmer climes, living in all four of the deserts that reach across the western parts of the continent.

Deserts are defined as regions of "deficient and uncertain rainfall," and those in North America are no exception, although only a small area in the Southwest conforms to the mental image of desolate sand dunes. The American deserts stretch some eight hundred miles across Idaho and Oregon,

and from this latitude southward into and beyond the Mexican states of Sonora, Chihuahua, and Baja California.

The least complex of the four is the Great Basin Desert, two hundred thousand square miles reaching from eastern California across most of Nevada and Utah, the western edge of Wyoming, southern Idaho, and southeastern Oregon. The predominant vegetation consists of low, microphyllous semishrubs, a single perennial form of plant life that includes the shadscale or spiny salt bush, *Atriplex confertifolia*, and the sagebrush, *Artemisia tridentata*. Trees are scattered parsimoniously across the landscape, and the whole basin is ringed by high mountains. North of the desert, the lizard lives in semiarid portions of southern British Columbia and southwestern Alberta, not too distant from the forested environment of the Pacific Northwest coastal zone. Only two species brave this colder region: *Phrynosoma platyrhinos*, the desert horned lizard, which lives in western Utah, Nevada, southeastern Oregon, and southwestern Idaho, and a small, hardy subspecies of *Phrynosoma douglasii*, the short-horned lizard, which lives in fifteen states and Mexico. As in the Southwest, the first settlers were familiar with the lizards, recording their presence long ago in South Dakota around Crow Buttes in Harding County, and beside Wounded Knee Creek in Shannon and Washington Counties.

In the Mojave Desert the Joshua tree, *Yucca brevifolia*, catches the eye, but even fewer trees than in the Great Basin Desert interrupt the skyline. Once covered by the Pacific Ocean, the sandy soils of the Mojave show reminders of the lava, mud, and ashes left from eruptions in the distant past. Now the extinct volcanoes share space with dry lake beds and small, isolated clusters of mountains. Bounded by the Sierra Nevada and the Colorado River, the Mojave Desert includes portions of southern California, southern Nevada, southwestern Utah, and northwestern Arizona.

Although the land can nourish fewer plants in the more

arid southern deserts, the variety is greater. Stony terrain, an ideal backdrop for the fragmented colors of the horned lizard, anchors different roots than the rivulets and dry washes of the alluvial fans, but the entire region is hospitable to one or more species.

The Sonoran Desert takes first prize for diversity. Slipping across the border into Baja California and Sonora, on the northern side of the border it lies in Arizona and southeastern California. This is the arid terrain beloved by Western movie-makers, the land of *Carnegiea giganteas*, the distinctive saguaros that thrust upward like sentinels guarding the emptiness. They share the desert floor with numerous cacti as well as saltbush shrubs *(Atriplex)* and *Larrea tridentata*, the creosote bush, which is found in most desert environments. *Phrynosoma mcallii*, the flat-tailed horned lizard, finds a niche here, as do the regal horned lizard, *Phrynosoma solare*, and the desert horned lizard. Paradoxically, more than half of the arid Sonoran is within fifty miles of a coast, and rivers, lakes, and irrigation canals that channel groundwater also abound. Indeed, the desert wraps around the Gulf of California, with mountains providing a scenic backdrop to the north and south.

The most southern of North America's four major deserts, the Chihuahuan Desert covers some or all of ten Mexican states before crossing the border to the southeastern corner of Arizona, southern New Mexico, and West Texas, including the extraordinarily diverse ecosystems of Big Bend National Park. Here the creosote bush, with its aromatic leaves, is the hardiest plant, and several species of agave thrive, especially the sharp-leaved *Agave lechuguilla*. Brilliantly colored flowers adorn the desert in spring before stoically conforming to less resplendent tones to endure the summer heat. The neutral colors afford protection from predators to horned lizards and other small animals.

Besides the desert species, other species of horned lizards

live along the California coastline (*P. coronatum*) and at altitudes where vegetation and rainfall demand a different lifestyle. In every habitat, camouflaging coloration allows them to blend imperceptibly with their surroundings.

The Norwegian-born zoologist Dr. Leonhard Stejneger, curator of the division of reptiles and amphibians at the United States Natural History Museum in Washington, D.C., in the early years of this century, wrote, "In the cedar and pine belts of the San Francisco Mountains the dark color of the soil and stones covering the surface is closely matched by the ground color of the *Phrynosomas*, while the greenish gray and orange colored markings, which somewhat irregularly adorn their backs, are perfect imitations of the lichens covering the rocks and pebbles among which these odd-looking creatures live. Near the rim of the Grand Canyon of the Colorado, on the other hand, the ground is covered with small pebbles of variously colored sandstone, ranging from a clayey white to brick red and dark brown, and the specimen which I collected there is such a faithful reproduction of the surroundings that it would undoubtedly have remained undetected had it not been moving."

Habitat and Geographic Range

*I*n North America, fossilized traces of plants have existed for the past four or five million years, among them the plants that thrived where today's true deserts stand. Intermittent ice ages have occurred over the past million and a half years, separated by more or less arid or rainy periods. Climatic changes over millions of years affected the range of many plants and animals. As ice sheets flowed and retreated, lizards, like other creatures, moved to live where conditions may previously have been intolerable. Grasslands that spread during the Pleistocene epoch, which ended about ten thousand years ago, provided a hospitable environment for horned lizards and continue to be a welcome habitat.

Since the last glacial period, the Sonoran Desert has remained dry. It may be from this region of the country that persistent lizards fanned out to reestablish themselves, traveling northward to occupy the Great Basin Desert, and into Nebraska, Kansas, and Texas. Fossilized remains have been retrieved from materials deposited during glaciation in South Dakota, Nevada, Wyoming, New Mexico, Kansas, and Texas.

The earliest ancestors of horned lizards were vertebrates that lived in the sea. Their descendants first clambered out of the water 350 million years ago, gradually developing the four legs that helped in their struggle to survive on land. After a further 200 million years elapsed, reptiles became the dominant vertebrates on earth. Some, like the enormous horned *Triceratops*, share a branch on the horned lizard family tree. Like birds, fish, and mammals, all reptiles have a stiff vertebral rod or a backbone. Reptiles distinguish themselves in several ways from other subjects of the animal kingdom. They are ectothermic, or cold-blooded; they pass through no larval stage, but produce their young in amniotic eggs;

and they have body scales, and several bones on each side of their lower jaw. Horned lizards belong to the reptilian order Squamata, which includes other lizards and snakes. They are kin to the Phrynosomatidae, among the most numerous of the twenty-two families of lizards. Phrynosomatids live on land or in trees and are active during the daytime. The horned lizards' closest relatives are the earless lizards of the genera *Cophosaurus* and *Holbrookia*.

Paleontologists with a penchant for investigative work have succeeded in identifying species of horned lizards from the single clue of a fossilized tooth. Generally, though, archaeological digs have yielded more generous remains. Almost seven hundred fossilized lizard bone fragments were found in the area of Split Rock, Wyoming. Dating back to the Middle Miocene, far older than other finds, the trove included the right jawbone of a horned lizard the length of a fingernail, with seventeen intact teeth.

The skull of another specimen, together with one horn measuring ten millimeters by five millimeters, was found in Meade County, Kansas, undisturbed since the Upper Pliocene. Its presence suggests that either the climate there was once warmer, or the lizards' needs have changed in the intervening millennia.

In Arkansas eleven horned lizard fossils from the late Pleistocene were retrieved from the Conard fissure in 1903, and bear a strong resemblance to the lizards living nearby today. Similarly, the ten-thousand-year-old fossilized remnants in the Frenchman Mountain caves near Lake Mead in Clark County, Nevada, are indistinguishable from their present-day descendants. Digs have revealed other Pleistocene *Phrynosoma* fossils in White Pine County, Nevada, and Millard County, Utah. Horned lizard fossils from the Quaternary period have been excavated in the Big Bend region of West Texas, lying close to the Rio Grande by Maravillas Canyon and by Tunnel View near Rio Grande Village. Not

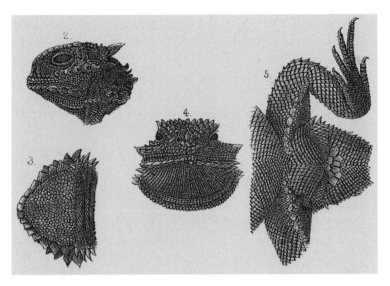

Charles Girard accompanied Howard Stansbury on his expedition to the Valley of the Great Salt Lake in Utah. Several horned lizards were sighted. The lithograph represents a dissected *Phrynosoma platyrhinos.*

many miles away, in New Mexico's Guadalupe Mountains, several hundred *Phrynosoma* teeth were found in Dark and Burnet Canyon caves. Scientists believe the Dark Canyon caves may have housed an owl roost. The remains in the Burnet Cave, blackened probably by fire, might be the leftovers of meals enjoyed by American Indians who lived in the region.

Each fossilized reminder of the past provides a link to the lizards' evolution. The physical descriptions vary in complexity and detail. Charles Girard, a team member in the exploration and survey of the Valley of the Great Salt Lake in Utah led by Captain Howard Stansbury, was intrigued by the unique appearance of the horned lizards he encountered. In a report of the expedition published in 1851, he described their bodies as "more or less circular in shape, always depressed, sometimes flattened, scattered all over with irregu-

lar and spine-like scales, the solid and subtriangular head provided with acute spines or tuberculous knobs."

In communication with his scientific colleagues, Alan Gentry informed members of the Academy of Natural Sciences in Philadelphia in 1886 that the lizard's general characteristics were: "Head short, cordiform, elevated at the vertex, and armed behind and on the sides with strong spines, variable in length and number. Cephalic plates small, rugose and polygonal. Palatine teeth wanting. Gular fold present. Auricular aperture inconspicuous in certain species, or entirely absent. Body short, rounded, depressed, and ordinarily fringed. Dorsal and caudal crests lacking. Limbs short, digits moderately developed. Tail comparatively short. Femoral pores present, but anal wanting."

His words dignified the small, unpretentious creature that scuttles around the underpopulated western regions of the country. True to their name, horned lizards look formidably like toads. Their bodies, sagging comfortably between their four legs, are adapted for absorbing rapid solar heating and providing space for numerous offspring. Also toadlike, they flick their tongues out to catch food, have rough skin and an awkward gait, and are able to inflate themselves to intimidate likely attackers.

A camouflaged appearance is essential, as horned lizards are by nature sedentary and slow-moving, though all are capable of short bursts of surprising speed, especially the flat-tailed horned lizards. Their coloration and patterning varies between individuals as well as populations, but in every instance affords the lizards their best chance of blending into the terrain where they live in order to avoid predators. The Texas horned lizard, whose range extends eastward beyond the Rockies, is a case in point. On the eastern boundary of their range, where trees are more plentiful, specimens are dark with sharply defined face bars and gray, thickly spotted bellies. Over the grassy plains they are lighter gray, and at

the western extremity, as well as the Rio Grande Valley to the south, they are brighter, with narrow face bars and white bellies.

One affectionate herpetologist wrote, in terms now out-dated, that the variation in color and markings of the "little gnomes of the sand" reminded him of "certain Indians who wear all manner of freakish masks in their dances and ceremonies."

Of the seven species that live in the United States, three prefer environments defined as arid, though only marginally drier than areas classified as semiarid; another three favor moderate desert conditions, and one opts for extremely hot sand flats. Just a single species is found in Nebraska, North Dakota, South Dakota, Wyoming, Washington, Montana, and east-central Texas. California has four species native to the state: the short-horned, coast, desert, and flat-tailed horned lizards. Arizona has six, with four species inhabiting the southeast corner of the state.

Most species live below the record elevation of the short-horned lizard (*Phrynosoma douglasii*), which can be found from 900 feet above sea level to as high as 11,300 feet. None-theless, their ranges vary, sometimes a great deal in a single species. Regal horned (*P. solare*), coast horned (*P. coronatum*), and Texas horned lizards (*P. cornutum*) live at sea level as well as at elevations over 4,000, 6,000, and 6,500 feet, re-spectively. Flat-tailed horned lizards (*P. mcallii*) inhabit places below sea level to 600 feet, and the desert horned lizard (*P. platyrhinos*) ranges from below sea level to elevations as high as 6,500 feet. Round-tailed horned lizards (*P. modestum*) stay above sea level, but can be found at 700 feet upward to 6,000 feet.

Before the German naturalist Arend Wiegmann bestowed the name *Phrynosoma* in his publication, *Herpetologia Mexicana*, the American Indian descriptor *tapayin* was used in Mexico and also adopted to classify species farther north.

They were sometimes referred to as *Anota*, a related genus, but nonetheless a misnomer. Each species of horned lizard has a Latin name, either immortalizing the man who recorded the first specimen, or a contemporary notable, or else derived from its appearance. Additionally, all carry a popular name, with two species known simply by the shape of their tails.

The most widely distributed species is the short-horned lizard, *P. douglasii,* named for David Douglas, who collected scientific specimens along the Columbia River in the early nineteenth century. Territorially divided among five subspecies, the short-horned lizard lives in fifteen U.S. states, southern British Columbia and Alberta, Canada, and south as far as Central Mexico. It is one of three species of horned lizard seen in West Texas, up in the Davis and Guadalupe Mountains. It has another distinction as the only species in the United States that is viviparous, giving birth to live young, rather than laying eggs, probably due to an evolutionary adaptation to the shorter summers and colder montane environment. At least four species found in Mexico are viviparous.

Phrynosoma mcallii, the flat-tailed horned lizard, is named for U.S. Army Colonel George M'Call. In the 1850s, he collected the type specimen in the northwestern Sonoran Desert, between Camp Yuma and Vallecito, now Imperial County, California. The primary flat-tail habitat is in three California counties, to the west of the Gila and Tinajas Mountains of Arizona, and on stretches of the Sonoran Desert that dip down into Baja California Norte and Sonora, Mexico. Preferred terrain is sandy desert flatland with sparse vegetation, surface soils containing loose or windblown sand, and areas covered with small pebbles. Some favor hillsides. Due mainly to urban encroachment, about a third of their historic habitat no longer supports the species.

Phrynosoma solare, the regal horned lizard, is named for

the spread of four central horns that are joined at the base, broader than they are high, and fan out like a crown or the sun's rays. The regal horned lizard lives only in central and southern Arizona and Mexico, enjoying the semiarid flats and valleys of the Sonoran Desert and the slopes of mountain foothills. Some choose desert scrub and cactus surroundings, while a few have been found in oak and juniper woodlands.

The desert horned lizard, *P. platyrhinos,* takes its scientific name from the Greek words *platy* (broad or wide) and *rhinos* (nose). It frequents the Great Basin, Mojave, and Sonoran Deserts, living among woody shrubs, yucca, and cacti on desert flats, and in washes and valleys.

The smallest species, *P. modestum,* recognizably translated to "calm" and "unassuming," is better known as the round-tailed horned lizard. For all its modesty, it can be seen over an expansive area. It is native to western Texas, where it frequents Seminole Canyon State Park in Val Verde County, southern New Mexico, southeastern Arizona, and south beyond the Chihuahuan Desert in Mexico. In 1846, a time when events on the border were particularly volatile, General Churchill came upon the previously unidentified species when he crossed the Rio Grande into Mexico at Presidio del Norte in the state of Chihuahua. Other military personnel were nearby, and a certain Colonel D. Graham and his party brought specimens from San Antonio to El Paso. Eight were duly delivered to the Smithsonian Institution. The roundtail prefers outwash slopes and other eroding surfaces, avoiding predators with the help of a natural camouflage that makes its presence all but undetectable amid the pebbles scattered across the ground.

P. coronatum, the coast horned lizard, lives farther west than all the other species. One or another of the five recognized subspecies is familiar to people in less urbanized areas along the western seaboard from northern California through

the Baja Peninsula. With slight differences in appearance and habitat, they are readily identified as the same species. The jury is still out on *P. cerroense*, the Cedros Island horned lizard, an isolate that dwells off the Pacific side of the Baja California coast and is considered by some to be a subspecies of *P. coronatum*.

Far and away the best-known species is *Phrynosoma cornutum*, the Texas horned lizard, the creature of popular folklore and once a favorite of curio dealers. Its native range is to the east of all other species, in the southern Great Plains and farther east of the Rockies, well distributed through Texas, Oklahoma, Kansas, and New Mexico, where it enjoys arid and semiarid open country with vegetation changing from cacti and mesquite to juniper and woody shrubs. Additionally, it is found deep into Mexico, quite frequently in Colorado and southeastern Arizona and, questionably, in portions of Louisiana, Arkansas, and Missouri. After the resplendent *P. solare*, this is the lizard with the most prominent horns. It has spiky scales all over its back and a double row of them along each side.

Behavior

When they are not preoccupied with getting warm, staying cool, finding their next meal, or avoiding predators, horned lizards enjoy socializing. At certain times of the year this tends to set in motion the next generation. Horned lizard behavior is determined by both heredity, which includes adaptation to the environment, and surrounding factors, especially the prevailing climate. The lizards need to be warm to trigger activity, but in the height of summer they curtail or change their pattern of activity to allow for longer periods in the shade. They also adopt a bimodal pattern of activity, becoming active early and late in the day but not in the heat of midafternoon. In fall and spring, the pattern changes and becomes unimodal, with activity occurring at midday.

Each day begins for the horned lizards when they use the vestigial energy conserved through the night to poke their heads up through the sandy earth. With their backs serving as miniature solar panels, they bask in the sun until the rising temperature galvanizes them into action. Once prepared, they will alternate positions throughout the daylight hours, soaking up sun, then seeking respite from its heat. As night falls they hollow out a subterranean resting place, first arching their backs, then lowering and vibrating their heads from side to side. Scales on their lower jaws provide the cutting edge before they hold their front limbs close to their bodies, wriggle in their heads and front sections, lower their trunks, and oscillate from side to side until all but the tips of their tails have vanished from sight. The mavericks, greedy for warmth, often sleep on blacktop roads, with dire results.

As with other members of the animal kingdom, the horned lizard's primary concern is food. As is true of the Australian *Moloch horridus*, an agamid lizard they resemble, the main-

stay of their diet is ants. In some species ants account for about 50 percent of their intake, and in others, more than 90 percent. Contrary to the general belief that these meek creatures sit and wait for food, horned lizards are active foragers, moving from one anthill to another to track down prey. Flat-tailed horned lizards have been observed along the edges of sand dunes west and south of Yuma, waiting patiently for half an hour or more on anthills with no signs of ants. When the lizards gave up and left, however, the hills swarmed with ants, as though they had been aware they were under surveillance. Horned lizards will lurk at up to six colonies for between five and seventy-five minutes at each site, eventually satisfying their appetites with two hundred to five hundred mouthfuls in the course of a day. They may plunder a single ant trail for several weeks, then make their way, often over considerable distances, to find another satisfactory source.

Stationary insects hold no appeal, as if, being motionless, they cannot actually be food. But small creeping bodies, and preferably those of hastening ants, will excite horned lizards, prompting a pantomime of tail-twitching, like that of a cat that has singled out a bird, and a jerky pacing toward the unsuspecting target. Once within reach, the lizard will make a final spurt, thrust out its sticky tongue, swallow the mouthful alive, then retreat. Neither the esophagus nor the stomach seems to suffer from protesting bites or stings. Yet when the situation is reversed, and ants attack a lizard, it will turn tail to escape because the ants can swarm the lizard and sting it to death. In the normal course of events food is taken from the advancing rather than the retreating end, and lizards debate their David-and-Goliath relationship with the victim, beating a last-minute retreat if they feel the sling of fortune unlikely to favor them.

To the uninformed, an ant is merely an ant, but the horned lizard is discriminating, where possible seeking out *Pogono-*

myrmex, the large red harvester ant that is now threatened by immigrant fire ants. The native fire ants pose no problem, but the exotic ones certainly do. These took a circuitous route from Brazil and arrived in Mobile, Alabama, in the 1920s, before extending their territory as far west as west Texas and east to the Atlantic Ocean. Some people blame fire ants (which horned lizards do not eat) for the declining population of horned lizards, citing the newcomers' audacity in climbing trees, invading bird nests, and killing harvester ants. Others consider that fire ants need not assume all blame, claiming that horned lizards were already disappearing before they arrived.

Although relished, ants are not an efficient source of nourishment. Composed largely of indigestible chitin, up to several hundred a day must be consumed to provide adequate sustenance for daily tasks, tissue-building, and reproductive capability. The necessary quantity also explains the inordinately large stomach size of horned lizards, up to 13 percent of their total body mass.

In the wild, food availability keeps species apart. For example, while the ranges of the Texas horned lizard, the round-tail, and the short-horn overlap in the Davis Mountains of Texas, these species do not share the same space. The short-horned lizard lives at a higher elevation, and the others partition resources, keeping their distance by foraging in different microhabitats. The Texas horned lizard prefers sandy flats; the round-tail opts for the rocky areas. In addition, the round-tailed horned lizard eats a different kind of ant than *Pogonomyrmex*. The two species seldom occur together.

In captivity, horned lizards enjoy greater diversity of diet. Back in 1916 a naturalist who cared for several species taken from the low, alkaline land in the western part of Salt Lake City described how he fed them on insects collected with a net from a nearby alfalfa field, including alfalfa weevil larvae, ants, bees, locusts, and their favorite, larva and adult Pieridae

(butterflies). One scientist in the early years of the century kept a short-horn alive for a year on large ants, grasshoppers, mealworms, and crickets, and some species, kept as pets, readily took flies or other small insects from the fingers of their keeper. Herpetologist John Van Denburgh, who wrote extensively on the reptile collections in the California Academy of Sciences collections, which already numbered forty-six thousand specimens by the early 1920s, was also taken with horned lizards. He allowed that a few drops of milk, placed in the cage, seemed to be enjoyed by old and young lizards alike. A colleague of his, who found two specimens along the Gulf of California coast of the Sonoran Desert, treated them to flies and cockroaches. More recently, the biologist Bertrand Baur, who has had a passion for horned lizards since childhood, advocates frequent small meals, with crickets as the preferred staple and small ants the most important supplement. Like hens with their fondness for ground oyster shells, and birds with their bent for gravel, horned lizards satisfy a particular but mysterious craving of their own by eating tiny pebbles.

Even for horned lizards, eating and basking do not constitute the full sum of their pursuits. Beyond focusing on survival skills, they are sociable creatures with their own kind and with human beings, who once enjoyed them as pets, but now, due to conservation concerns, must restrict their involvement to scientific research. Many are the tales of remembered childhood, wondrously hypnotizing the horny toads, like birds, by stroking the tops of their heads and between their eyes to reduce them to a trance. In a stupor that might last for ten minutes, the lizards could be turned on their backs or tweaked with tweezers and remain impassive, allowing a gratifying sense of power to the perpetrator.

On occasion their social behavior might better be termed antisocial, for in hot weather males tend to fight if confined in close quarters, many of them wagging their tails with an-

noyance. Larger specimens have even resorted to physical abuse, dragging smaller ones around by the tail (which doesn't easily break off) in their mouths. When angry they will arch their backs, point their snouts toward the ground, and hiss expressively as they make little leaps in the air.

Males claim territory by a practiced ritual that inhibits the intrusion of other males, either biting them or standing on an edge of their adopted claim and bobbing their head vigorously. If they are subjected to retaliatory head-bobbing, they move on to the next tactic, a series of push-ups—but warily, lest this attract the attention of predators. Head-bobbing also serves as a formal introduction, a silent free-masonry greeting that might lead to further, more complex interaction.

When the bobbing occurs between a male and a female, and the female is receptive, the relationship develops fast, to the point of sexual intercourse. This is the beginning of the reproductive agenda and likely will occur during the mating season between April and July. Courtship, copulation, impregnation, gestation, and delivery or laying and hatching follow an established sequence within a species or subspecies, and between subspecies. Hybrids between two species have also occurred in captive lizards. The ardor of one partner is not always reciprocated. A brief tale of courtship describes how one pair was observed for an hour and a half, the male lying on top of the female, clutching the nape of her neck. She, meantime, bobbed her head, did a few push-ups, swallowed a couple of insects as they crawled by, and walked a few feet, carrying her prospective partner along, still attached to her back.

Soon after mating, the female undertakes the responsibility of finding a suitable location for a nest, and this may occupy several weeks. Now, with horned lizards less evident in populated areas, it is unlikely nests will be seen. But in the past, Baylor University in Waco was a hotbed of recorded

horned toad activity. John Strecker was a favorite son of Baylor. A biologist and folklorist, he wrote detailed accounts of their presence, including the discovery by Mr. Whipple, the university's engineer, of a lizard struggling to prepare her nest in the hard earth at the back of the engine house. Perhaps the poor creature was desperate, for the usual practice is to consider the degree of soil moisture, drainage, and ventilation, and the degree of surface exposure to the sun's rays. The eggs become vulnerable if they are not well protected, as drought will reduce their water content and wrinkle the shells, making them easy prey for ants. By the same token, heavy rainfall can erode the soil, leaving them unprotected. Sometimes a number of false starts are made before the ideal spot is found.

The lizard excavates her nest by scrabbling out the earth to make a sloping tunnel, digging with her front feet and kicking away the dirt with the hind ones. It will take an hour's work to hollow out a space three or four inches across and six to eight inches below the ground before she feels confident to start laying her eggs one by one. The average clutch size ranges from five to twenty-seven eggs, with the desert horned lizard laying as few as two and the Texas horned lizard as many as thirty-seven. Both the flat-tailed horned lizard and the desert horned lizard can lay more than one clutch in a breeding season. Most mothers-to-be will arrange them in two or three layers, sometimes rolling each one in dirt, like raisins in cake flour, to prevent their sticking to each other, and to make them inconspicuous to prowling predators. The eggs will lie in the nest for five to nine weeks. Their shells are tough, leathery, and non-calcareous rather than brittle, averaging five-eighths of an inch in length and almost half an inch in diameter. Most are yellowish-white, though they may absorb the colors of their surroundings. Almost-black eggs have been retrieved from a nest in a bank of coal dust and cinders.

Her task accomplished with a top layer of dirt, the horned lizard hides the tunnel and nest with dirt and rests on the tunnel entrance overnight. Then she leaves, forever. During their productive lifetime, lizards will lay hundreds of eggs, but on average two lizards from each clutch are expected to survive to adulthood, so that any slight change in mortality tips the population balance.

The one viviparous species in the United States, *P. douglasii*, delivers in July or August after carrying the embryos for up to three months. On average, about twenty-three live lizards will appear, with the mother squatting on her hind legs to drop a single baby and taking a couple of steps before depositing the next, along with a drop or two of fluid. The neonates lie still for several minutes, then wriggle out of the fragile, transparent membranes surrounding them, gasp momentarily for breath, and crawl a few steps before stopping to dry off. The mother has accomplished her mission and ignores them.

Within a few hours the babies are able to take care of themselves but may well have precarious beginnings. Neonates and newly hatched lizards are very susceptible to predation, in part because they lack well-defined horns. With little awareness of their surroundings, they are vulnerable. In Texas, John Strecker mentioned the abundance of young scattered over the Baylor athletic field each summer.

Around mid-October, as the first norther races southward across the Great Plains warning of winter, the lizards begin to burrow underground in preparation for hibernation. Those in captivity need the same cold spell, and are placed in refrigerators, the domestic kind or laboratory units, where they will stay from November until April at a comforting five degrees Celsius.

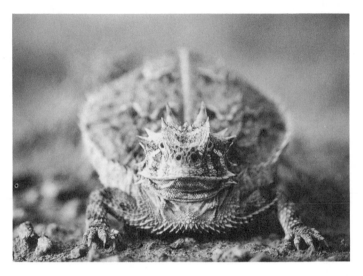

The horned lizard can inflate its body to threaten potential enemies more effectively. (Wyman Meinzer)

Defense

*D*espite their shortcomings, horned lizards have managed to hold their own against natural predators. Mammals, birds, and reptiles list *Phrynosoma* on their menu, although none target it as a mainstay as the lizard does the harvester ant. Human interference poses a substantial threat, and this is a factor with which the lizards are ill-equipped to deal.

When threatened, horned toads have three basic means of dealing with predators. First and foremost, they try to avoid detection. If spotted, they will bumble off as fast as they can. Last, they can draw on a series of tactics to effect an alarming change, switching from Hyde to Jekyll in a twinkling.

Their sequence of defense—hide, flee, or attack—begins with instinctual efforts to blend sufficiently with their surroundings to avoid being seen. Camouflage, a first line of defense, combines coloration similar to the terrain and "disjunct" coloration, which breaks up the body into fragments, such as dark bands on tails and blotches on the neck and sides. When confronted by predators that reject carrion, the lizards will first play possum, feigning death until the enemy loses interest and seeks gratification elsewhere.

Although lizards on the eastern boundary of the range tend to be darker than those in the western deserts where the ground is usually lighter, this generalization inadequately defines the possibilities of color differences. By being indistinguishable from the terrain on which they live, horned lizards are not readily spotted either from the air or at ground level. Within a species, coloration can be remarkably varied, and even in a single population noticeable differences occur if background shades vary. Flat-tails living on the edges of dunes in Sonora, Mexico, are redder than their cousins living an hour or so to the north, on the whiter dunes in Thou-

sand Palms in Riverside County, California. The round-tail ranges over several earth tones and soil types between the Pecos River and the Rio Grande. There are red alluvial soils in New Mexico, between the Pecos River and the Llano Estacado, the staked plains region. Farther west, from the southern Rockies down to the Pecos valley, the soils are gray-ish. Even more dramatic, colors in the Tularosa Basin shift from the near-black of ancient lava flow to gypsum deposits which are almost white.

Besides color disguise, a cryptic appearance often proves a lifesaver. Humans and animals alike tend to see what they expect to see. When a lizard's appearance is changed, essentially creating an optical illusion, the creature's perceived identity changes too. The lizard, for all intents and purposes, becomes a part of the scenery, and may look different if seen up close or from a distance. This passive mimicry is advantageous. Designs patterning the skin cloak the animals as effectively as the camouflage clothing worn by soldiers and hunters.

If the horned lizard stands motionless on the background nature intended, it looks like a rock to predators, unseparated from the pebbles and gravel strewn around the shrubs and grasses. A dorsal stripe adds to the predator's confusion rather than attracting notice. As the stripe bisects the lizard, the animal actually appears to be not one rock but two, and the stripe itself seems detached, like a blade of grass or a twig. When the lizard lies low, endeavoring to flatten itself, this increases the deception by virtually eliminating any shadow. Lateral spines surrounding the lizard's torso contort the shape still further, softening and obscuring the edge of its body. This is an important defense against predators who depend on sight and movement to catch their prey.

The round-tailed horned lizard (*P. modestum*), which has no stripe on its back and only short horns and dorsal spines, must try especially hard to defend itself. It relies on uncanny

behavior called rock mimicry. Hunching its body over, the lizard bulges its back up to look like a stone. Aided by dark splotches on its neck and back, it relies on total immobility to fool attackers.

Sometimes, when the bluff is called, the clumsily gaited lizard has to make a dash for it. Again nature helps out, for if the sprint is followed by a "freeze," the predator will be nonplussed when the lizard essentially disappears while in full view. Predators are unable to halt their eye movement as fast as the lizard stops.

On occasion, attack is the best means of defense, and the horned lizard has a remarkable capacity for trickery. Naturally docile and passive, the awkward little reptile becomes transformed into an aggressive monster, intimidating even the largest, boldest enemies. The metamorphosis begins with a literal change of direction. Rather than presenting its more vulnerable rear end, the lizard whips around to face its aggressor. Thereafter the program depends on the enemy. The lizard can enlarge itself spectacularly, inflating to the point where it bounces indignantly on its belly rather than standing foursquare on its feet. This disconcerts snakes, which are inclined to weigh the relative magnitude of themselves and their next meal. The lizard appears too broad, plump, and spiny to be palatable. Even by just standing its ground, the lizard gives the impression that sharp horns will cause discomfort or even damage to a predator's soft mouth. Normally silent, the lizard hisses and lunges with its mouth open, menacing like a miniature dragon. The tail vibrates and is especially effective amid the rustle of dry leaves.

The unique practice of blood-squirting is the horned lizard's *coup de grâce*. This was first noted and recorded by Spanish expeditionary parties in Mexico, but word did not get around. It was not until the nineteenth century that North Americans began to exchange scholarly but rather charming accounts of the phenomenon. In 1892 the *Pro-*

ceedings of the National Museum included a short article entitled "On the Ejection of Blood from the Eyes of Horned Toads." The author, O. H. Hay, was brimming over with excitement after witnessing a startling performance:

"About the 1st of August it [his captive horned lizard] was shedding its outer skin, and the process appeared to be a difficult one, since the skin was dried and adhered closely. One day it occurred to me that it might facilitate matters if I should give the animal a wetting; so, taking it up, I carried it to a wash basin of water near by and suddenly tossed the lizard into the water. The first surprise was probably experienced by the *Phrynosoma,* but the next surprise was my own, for on one side of the basin there suddenly appeared a number of spots of red fluid, which resembled blood. . . . A microscope was soon procured and an examination was made, which immediately showed that the matter ejected was really blood.

"The affair now became very interesting. Just where the blood came from I could not determine with certainty, the whole thing having happened so suddenly and unexpectedly; yet the appearance seemed to indicate that the blood came from the region about one of the eyes. There appeared to be a considerable quantity of the blood, since on the sides of the vessel and on the wall I counted ninety of the little splotches. A consultation was had with Dr. Stejneger the next day with regard to the propriety of dashing the animal into the water again to discover, if possible, where the blood came from. It was thought, however, that such blood lettings must be somewhat exhausting, and that it would be better to allow the animal a day to recuperate. While talking, I picked up the lizard and was holding it between my thumb and middle finger and stroking its horns with my forefinger. All at once a quantity of blood was thrown out against my fingers, and a portion of it ran down on the animal's neck; and this blood came directly out of the right eye. It was shot back-

ward and appeared to issue from the outer canthus. It was impossible to determine just how much there was of the blood, but it seemed there must have been a quarter of a teaspoonful. I went so far as to taste a small quantity of it, but all that I could detect was a slight musky flavor."

Today scientists are still undecided about the precise reason and mechanics of the practice, though now they recognize it as a form of defense. Early investigators suggested it might be due to a part of the cornea damaged by a parasite or else be linked to the periodic skin shedding. Others thought it occurred solely during the breeding season, but this was refuted after a report was published about a young specimen, no longer than an inch and a half, already able to squirt blood.

In the United States, *P. cornutum, P. coronatum,* and *P. solare* are best known for their blood-squirting prowess, and in Mexico, *P. orbiculare* and *P. taurus.* To prepare for the show, some species will arch their backs and close their eyes. The eyeballs begin to protrude and the eyelids then swell as they become engorged. Blood may be sprayed from one or both eyes, and shoot up to four feet in distance either forward or backward. The discharge lasts only a moment or two, and may be repeated two or three times, with a second performance possible a few minutes later. While Hay found the blood almost tasteless, canines, including dogs, foxes, and coyotes, find it extremely unpleasant, so it serves well to deter their intentions.

In the same way that defense tactics differ, so do the attackers' approaches. Many predatory birds have strong talons and hooked beaks so they can dismember their victims. Roadrunners, the Southwest's beloved *paisanos,* take prey in their beak and whack it vigorously on the ground to shatter the bones and make their tidbits easier to digest. Hawks can spot full-size horned lizards from an altitude of three thousand feet, sometimes even the most cleverly disguised

ones, but they, like shrikes, have been known to suffer fatal punctures from sharp horns.

Snakes swallow their prey whole, and they have sometimes self-destructed, fatally wounded by horns piercing their throats. Certain American Indian tradition holds that horned lizards can burrow their way out of a snake's stomach. This may have some factual basis, as the heads of horned lizards have been extricated from the heads of snakes, with their horns sticking through the body wall as well as the throat.

Mice, although usually innocuous, have succeeded in killing captive *Phrynosoma* that were too cold to counter the offensive, but more often it is canines that attack. At one time, in the first years of European settlement in the West, the domestic cat was a formidable human-sent enemy, second only to the insatiable curio collector. Now that populated areas have all but lost their horned lizard communities, cats and other domesticates cannot menace them. The threat to the species has become an environmental issue, and the challenge to the ecological chain persists.

American Indians

*T*he Salton Sea in California, lying 241 feet below sea level, was formed when the floodwaters of the Colorado River crashed through the canal headgates south of Yuma, Arizona, in 1905. For two years the river hurtled into the Imperial Valley until the damage could be corrected. Long centuries before this, the ancestors of the Cocopa people lived in the mountains overlooking Cahuilla Lake, where the Colorado and the Gila Rivers flowed into the valley from the northeast. Gradually the climate changed. Less rain fell, and the weather grew warmer. The waters receded, the lake dried, and the rivers began to converge on each other near Yuma and snake their way down to the Gulf of California. As the lake evaporated, it is said that Kinakul, one of the mountain people, sent Hiesh, a horned lizard, to see if the land was dry. When the lizard reached Laguna Salada he came upon *nypá*, the salt-grass *Didstichlis palmeri*, and saw it was ready for gathering. He broke off spiky ears of the wheat and stuck them in the top of his head as a sign that the waters had receded and he had found nourishing food. To this day the horned lizard carries reminders of the *nypá* on his head.

This legend illustrates the horned lizard's folkloric presence in the Southwest. Fascination with the exotic creatures on one's doorstep can be formally dated to 1842, when the American Ethnological Society was launched. Early anthropologists, intrigued by unfamiliar cultures, paved the way for establishing the Bureau of American Ethnology in 1879. A division of the Smithsonian Institution, the Bureau set out to gather objects for the museum's collections, publish reports, and classify American Indian languages. Scholars chose to spend physically challenging but intellectually and

[29]

socially energizing months out in the field, far from their desks. The southwestern reaches of the United States lured several men and women who produced detailed reports of traditional lifestyles flourishing far from the growing urban centers, entrenched in a wealth of folklore and mythology in the landscape, vegetation, and animals of their surroundings.

The regions the anthropologists and their successors chose to study lay in three dominant culture areas that virtually matched major natural zones. They devoted their energies to learning about the Anasazi, ancestors of today's Pueblo people, including the Hopi and Zuñi who lived in the region known as the Four Corners, where New Mexico, Arizona, Utah, and Colorado come together. Excavations in Mesa Verde and Chaco Canyon have revealed magnificent sandstone architecture and the distinctive Anasazi pottery.

The Mogollon also attracted close attention. They dwelt immediately south of the Anasazi, in a narrow swatch of Arizona that curved southeast through New Mexico, the southwestern tip of Texas, and into the Mexican states of Chihuahua and Sonora. Most notable among the Mogollon, the Mimbreños or Mimbres people lived in a small New Mexico valley near today's Silver City.

Between 300 B.C. and A.D. 1450 the Hohokam, "those who have vanished," lived in the low, irrigated desert country of southern Arizona. The Hohokam were ancestors of the Pima and Papago peoples. At the archaeological site of Snaketown, about a kilometer from the north bank of the Gila River between Sacaton and Chandler, several caches of buried items were found, with no identifiable link to the houses or other buildings close by. Many had been demolished either by force or by fire.

By the mid-fifteenth century the Colorado Plateau was almost deserted. The Anasazi, Mogollon, Hokokam, and other groups had disappeared from the region, most settling in New Mexico's Rio Grande Valley. Once an advanced and

A wooden horned toad fetish. The effigy was among the artifacts anthropologist Frank Russell acquired from his stay among the Pima Indians in southern Arizona during 1901–1902.

thriving region, the efficient canal network is now abandoned, and the few who still live here pursue a marginal existence belying their former cultural wealth.

While the eagle, coyote, and serpent played leading roles in traditional Southwestern lore, the horned lizard remained a stalwart adherent, appearing as fetishes, on pottery and petroglyphs, and in songs and stories recounted by one generation to the next. It was associated, for example, with the Horned Water Serpent in an elaborate Zuñi kiva mural. Similarly, in Hohokam art tradition, snakes and lizards, including the horned lizard, were favorite subjects, and were depicted in relief rather than in the more familiar painted style.

The Mimbreños, whose traditions and ceremonial structures date back to the years A.D. 1050 to 1220, created outstanding pottery. Hundreds of hemispherical bowls have been found in graves. Modeled in gray clay, they were generally covered with a fine white clay kaolin solution and decorated with black iron ore paint. The decorations included elaborate geometric designs and numerous simplified figures of humans and animals. In many instances the figures were painted in active settings, so that the pottery portrays an almost photographic record of daily life practiced a thou-

sand years ago. On the clay bowls and dishes, the horned lizard was painted either true to form or with droll dimensions like a caricature. A contemporary art historian suggests that the horned lizard was a harbinger of spring, like the tarantula, and was probably depicted as this symbol and for the clear silhouette it provided rather than because it held a particular mythic significance.

When the anthropologist Frank Russell studied the Pima tribe on the Gila River Reservation in southern Arizona in 1901–1902, he collected over three hundred artifacts and countless oral traditions in his house-to-house interviews. The farmers he met called themselves the River People and saw themselves as separate from the Papago, although they shared a linguistic heritage. Their poverty, and perhaps Russell's sympathetic interest, induced them to part with treasures including horned toad fetishes and effigies used by medicine men.

American Indians in this region still respect the lizard's place in everyday life and its power to change fortunes in health and happiness. Although the ferocious appearance of *P. douglasii* belies a harmless disposition, and no inclination to bite, a belief persists that the short-horn can produce a poisonous wound with its blunted spines. Mostly the horned lizard is incorporated into the ritual of health and sickness. Traditional Pima Indians recognize two forms of sickness. The "wandering sicknesses" are straightforward, caused by germs or digestive disorders. The *ka:cim* or "staying sicknesses" are more elusive, neither contagious nor infectious. Such afflictions, diagnosed only by shamans, are contracted by improper behavior toward a dangerous object. With no biological cause, only the intervention of Piman ritual healers can effect a cure. Most offenders, among them the horned lizard, are desert animals as varied as the vulture, owl, quail, rabbit, squirrel, and turtle. The diseases can be contracted unknowingly—for example, if a lizard or other animal is

inadvertently killed or injured. Customarily, if one were to accidentally step on a horned toad, even if no serious injury appeared evident, it was deemed wise to tie a red string around the creature's neck and let it go, saying, "*Nyu u-ut hok*—my blood eat." In this way the lizard could ingest the "bad blood" and prevent disease from developing. For the less fortunate, the injury incurred from a misplaced footstep might not be manifested immediately, but then soreness, pain, and swelling in feet, legs, hands, and back sometimes occurred. On occasion, the systemic toxicity of a bite proved fatal. Less lethal effects attributed to bites included the chance of developing rheumatism or a tendency to hunchback.

Traditionally, shamans began their curing efforts by singing horned toad songs and applying carved wood, leather, or clay effigies to the painful area. Russell, who meticulously recorded everything he saw and heard during his several months in Arizona, remarked that the medicine songs were a tradition among the Papagos. The medicine man's songs interwove the remedy with dreams:

> A little grey horned toad
> Came out of the darkness.
> Right around he twisted,
> Stretched out his neck
> And spoke to me.

One medical story has drawn considerable academic curiosity over the years. A woman named Sala Hina suffered dreadfully after unwittingly eating poisonous weeds. Feeling "full of pins," she was attended by first one and then a second medicine man. Neither was able to help. A third was called. He went through the established practice of singing relevant songs, then smoking a cigarette and puffing a cloud of smoke over her body in an attempt to locate the cause of disease, which he judged was deeper than the diagnosed food

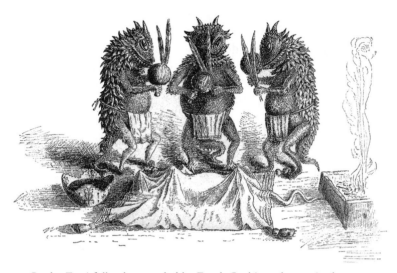

In the Zuñi folk tale recorded by Frank Cushing, three priestly horned toads begin their incantations over a mouse shrouded by a blanket.

poisoning would warrant. Eventually, as her agony intensified and she seemed close to death, a fourth healer discerned a horn, from a horned lizard, stuck in her heart. He sucked and sucked her mouth until he withdrew, gagging, having extricated a burning hot horn, which was then wrapped in cotton and flung into the river nearby. The singing continued, and after four songs dedicated to the horned lizard, she was cured. Different versions of this account have been closely analyzed, but no validation made.

Not all the horned lizard tales are so violent. In addition to having a compelling appearance, which adorned pottery, stone outcroppings, and cave walls, the small animals have long held a place of affection in American Indian legends and songs. The Zuñi tell the tale of a skillful young hunter who was turned into a mouse by a jealous wizard who then tried to abduct his wife and take over his home. A coyote-

being came to the rescue and took the mouse to the underground lair of the Great Horned Lizard Medicine Band, where aged horned lizards, almost as large as humans, were aroused from their hibernation to help. The mouse was placed before the altar fire, and a magic crystal heated in the embers. The master priest and his warriors carefully laid a cover over the mouse, then dipped their medicine feathers in magic water and shook the drops over the blanket. Lifting the corners, they touched the glowing crystal to the tiny paws and head, and restored the hunter to his true form.

Today, the Zuñi continue their 1,500-year-old practice of animal carving, using materials from as far away as the Pacific Ocean and the Gulf of Mexico. Old legends add a poetic and ritualistic dimension. One such legend recounts that the Twin Sons of the Sun Father resolved to help humankind by turning threatening animals into stone and destroying them. When rock outcroppings produce formations that look like animals, these bring good fortune in hunting. Carved animals also bring good luck, and the Zuñi have placed them in their homes and storage bins, as well as out in the fields to protect crops and livestock. The carvings have no religious significance until blessed by a priest, whereupon they are recognized as fetishes. They may then be set on altars and included in ceremonials.

A complex Navajo myth casts the coyote as villain pitted against a horned lizard. Humans hear a horned lizard singing instructions to the coyote to "come pick corn with me, but not touch the sacred stalk." The coyote satisfies his appetite on all the white and yellow corn and finally, as expected, begins to munch on the sacred stalk in which the lizard has hidden. At once coyote is overcome by a terrible pain in his throat and chest, caused by the lizard kicking and pulling. The pain continues until the coyote opens his mouth and allows the lizard's song to emerge. This pain is explained as a punishment for breaking the rules by taking corn from

the sacred stalk. The song implies that the lizard is sacred because it was able to defeat the coyote. The horned lizard is revered in ceremonies held for Navajo warriors, to protect them from within. The slightly obscure moral is that we are our own worst enemies. Perhaps in deference to this special strength, the Navajo have a taboo against including certain animals, among them horned lizards, in their rug-weaving designs.

The Moccasin Game was formerly an intricate pastime in the Southwest. One hundred and two guessing sticks were used as counters to pay points back and forth. A small ball was hidden in a moccasin, and players had either to guess which moccasin held the ball, or at least come close to iden-tifying the right one. The "moccasins" of several animals were included, like the badger and gopher, and each had a song they sang when they found the ball. The songs cannot be identified readily with the animals' special attributes, but the longest by far is the one the horned lizard player gets to sing:

> Oh, see what I have killed,
> Oh, see what I have killed.
> Standing here looking at it,
> I place the ball in the same moccasin
> for you,
> In the same moccasin for you.
> It is in the same moccasin, the same
> moccasin.
> No, it is in a different moccasin.
> The one who carries back the ball
> Now places it in another moccasin, an
> outside moccasin.
> The one who carries back the ball
> Now places it in another moccasin, an
> outside moccasin.

In a few instances, the lizard is linked with the weather. One song is mindful of a superstition on the Mexican border. It suggests that hanging a horned lizard from a tree will invite rain:

> The little red spiders
> And the little grey horned toad
> Together they make the rain to fall;
> They make the rain to fall.

Few tribes in the North mention the horned lizard, although its range extends hundreds of miles above the Southwest. The Yakima people of the Columbia River region believe the lizard will send bad weather if mistreated. They also link the animal to medicine, respecting it anthropomorphically as a doctor who cures by blowing healing breath on the diseased part of the body.

Southward beyond the United States border, the myths, legends, and superstitions date back beyond the time of early Spanish exploration in Mexico.

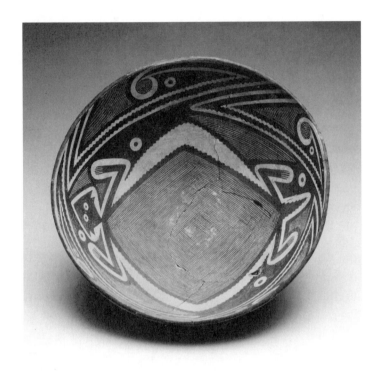

Mimbres bowl with horned lizard design. (The Heard Museum)

Folklore

*M*exicans have two names for the horned lizard: *camaleón* (literally, "chameleon") and the more appealing *torito de la Virgen*, the "Virgin's little bull." The *torito*, because it sheds tears of blood, is known also as the sacred toad, forging a connection with other animal myths clustering around the Christ. In selecting names, Texans are more prosaic, and John Strecker wrote, "This well-known reptile is commonly called Horntoad, Horned Toad, and Horned Frog. Many cowboys simply call it 'Toad.'"

The name "horny toad," not "horned lizard," evokes memories of the golden days of youth when the "critters" were everywhere underfoot. Superstitions are scattered across the Southwest and along the borderlands. A greater wealth of folklore material would exist if the native range extended farther east, absorbing more of the imaginative African-American cultural memories. One tale that dates back several generations in rural East Texas concerns a woman who became enraged at a girl who was trying to steal her husband. The woman visited a "hoodoo" doctor who told her to "kill a horned frog, salt it like salt pork, cook it with cabbage, and feed it to the girl." The victim went plumb crazy and had to make a trip to Louisiana to find a cure from a "hoodoo" doctor there!

In and around the Brazos Valley many were convinced that when the lizard "spat" blood, its bite was sure to kill. Others believed horned lizards to be slightly less lethal but extremely poisonous, still probably because of their blood-squirting, a characteristic that had a benign religious significance farther south. Elsewhere, inexplicably, death was seen as inevitable if one were bitten by a brown horned toad with a blue tongue. Yet another Southwestern superstition

relished prolonged suffering, declaring that stepping on a horned toad would cause a bump leading to a sore that would not heal. As it worsened, the foot would rot away.

The lizard is respected as a rainmaker, and on the border of Texas and Mexico one is hung from a tree to produce the desired effect—though my source was unsure if the lizard needed to be dead or alive to help. Perhaps influenced by this belief in the efficacy of lizards as rainmakers, a West Texas rancher convinced his grandchildren that if horny toads were dead all you needed to do was turn them belly up and water them, and they would come back to life. This was certainly a more palatable piece of folklore than a rural West Texas phobia that predicted that if you killed a horned toad your mother's cows would go dry or give bloody milk.

Schoolyards in West Texas were the meeting places of horny toads and children. As a form of flirtation rather than threat, boys picked them up to chase girls around during recess. Girls, in an age when roles were less equivocal, often treated the creatures as babies or dolls, scooping out a hollow in the dirt to serve as a cradle before soothingly stroking their tiny foreheads to hypnotize them.

Other youngsters tortured the lizards, or took potshots at them with a .22 or BB gun, running over them with bicycles or, worse yet, using and exploding them as firecracker cases. Again to the rescue, girls undertook mercy missions, gathering the survivors in buckets, then naming them as though the anthropomorphic gesture brought protection. Those they found too late were buried carefully, the Lord's Prayer recited, and a little flower placed on each grave. Despite this reverence, foreign cousins, even from across the state, were teased that cockleburs were actually horny toad eggs.

In the spring when the lizards emerge from hibernation, tradition has it that they will ravenously attack a red ant bed. The indignant queen of the nest sends out a scout to

see if the lizard is thin enough to be set upon and stung to death by her soldiers.

Not only ants were invited to take a tasty morsel. In the heyday of the curio trade, one store in Pasadena, California, advertised a unique twenty-five-cent delicacy, "Delicious horn-toad sandwiches positively our own make." Adventurous customers were treated to a lizard peacefully lying between two slices of bread, the snack tied together with string.

Such was the lizard's mythological stature, many cowboys were convinced that the lizards could live without food or water for a hundred years. But the life expectancy is about fifteen years, and the myth is just a tall tale likely based on the fact that during hibernation they can survive without evident nourishment for several months.

No horny toad story, however far-fetched, can vie with the legend of Old Rip of Eastland County, Texas. During the 1897 dedication ceremony for the cornerstone of a new county courthouse, Justice of the Peace Ernest Wood saw his son Will playing with a horned lizard and decided to place it in the cornerstone's time capsule to add appropriate flair to the occasion. Thirty-one years later, when the courthouse was demolished for replacement, an audience of three thousand gathered to see how the lizard had fared. Judge E. S. Pritchard removed the Bible and other objects from the cavity, and saw the toad still down there. A local oilman, Eugene Day, thrust his hand down and retrieved the dust-covered lizard. Carefully he passed it over to Frank Singleton, pastor of the First Methodist Church, who in turn handed it to the judge. Thereupon Old Rip awoke. The crowd went wild. Nobody doubted the lizard's longevity—or at least no one voiced any doubt. Then came the grand tour when Old Rip attracted national attention as he was exhibited across the country, even visiting President Coolidge in Washington, D.C. Too much excitement or exhaustion took its toll. Old Rip died of pneumonia and was laid to rest

in a plush-lined casket in Eastland's new courthouse lobby early in 1929. Over the years, and over a couple of beers, several have claimed responsibility for palming the original dead lizard and producing a new live one.

Lilly Daché, a successful French milliner in prewar New York, had heard about Old Rip when she drew up plans for a building to house her business. Her friend Alice Hughes, the wife of congressman Leonard Hall, who was then head of the Republican Party, procured a horned lizard to sit in the cornerstone foundation along with a variety of sentimental memorabilia. The story received press coverage, then the unwelcome arrival of two representatives of the SPCA, the Society for the Prevention of Cruelty to Animals, who demanded that the foundation be torn up and the lizard released. The headlines denounced Daché's cruelty. Not long after, her friend confessed that the whole episode was a publicity stunt, and as an apology presented her with a bejeweled box for the lizard.

The different attitudes to Old Rip and the Lilly Daché fiasco demonstrate the Texas disposition to elevate palpable fakery to myth. About the time Old Rip went into his prolonged hibernation, Texas Christian University was adopting the horned lizard as its mascot. Little Addie, or more formally Addison Clark Jr., son and nephew of the school's founders, Addison and Randolph Clark, introduced football to TCU, then known as Add-Rand Christian University, in 1897, while the campus was still based in Waco. Naming the team the Horned Frogs was a shoo-in, as the field was always alive with the lizards. Taking their talisman one step further, the first sidelines mascot, Addy, made his debut in 1949, a six-foot-tall purple apparition operated from within by an undergraduate who subsequently taught on the journalism faculty at the University of Oklahoma. A live lizard was kept as the school's mascot, but the succession of replacements came to an end when "Miss Froggy" died in

1984. A Fort Worth taxidermist did the honors for twenty-five dollars before she was put on display. The latest representation is a six-foot statue of cordoned steel crafted in Libertyville, Illinois, in 1984. The artist, Seppo Aarnos, was a guest at the unveiling that year when TCU Chancellor William E. Tucker participated in the ceremony by cutting a purple ribbon in the mall separating two campus buildings.

In popular culture the horned lizard has not always been represented literally, nor even quite figuratively. When the Santa Fe railroad forged a link across the West, the Rio Grande division, a segment from Albuquerque to El Paso and its branch lines in New Mexico, was always called the Horny Toad. The name supposedly came about because of a bizarre problem when the first small engines steamed through the Jornada del Muerto basin, west of the San Andres Mountains. The wheels lost traction on the rails made slick by the grease and moisture of hundreds of squashed horned lizards. The brakemen and firemen would climb down and sweep them off the track, giving rise to a type of character known as the "Horny Toad Man." Personnel viewed the segment as a proving ground for "those who wanted to advance to a managerial position with the Company. Everything that has ever happened on any railroad," they declared, "has happened on the Horny Toad." The Horny Toad Man, whatever his job, had to be prepared for all eventualities.

The same backhanded compliment found its way into verse. When Iowa lawyer E. V. Cook came to manage the holdings of the Keystone Land and Cattle Company near Pearsall, south of San Antonio, he found Texas hard to fathom. But he was captivated. In affection rather than disdain he penned a poem that achieved far more notice than he had ever dreamed. The lengthy "Hell in Texas" recounted the tale of the Devil requesting permission to try his hand at creation on any leftover land available.

The Lord said "Yes, I had plenty on hand
But I left it down on the Rio Grande.
The fact is 'old boy'—The stuff is so poor
You cannot use it in hell any more . . ."

The Devil rises to the challenge:

He fixed up thorns all over the trees
And mixed the sand with thousands
 of fleas,
Tarantulas scattered along the roads,
Put needles on cactus, horns on toads . . .

The horned lizard was extolled in verse by Nancy Richey Ranson, who for many years wrote a gardening column in the *Dallas Morning News* and was honored as the Texas Poet Laureate. In an early collection of poems written for children, "The Horned Toad" mildly forfeited scientific accuracy.

The horned toad is able to change his complexion
Whenever he chooses. While crossing a section
Of desert, he takes on the color of sand;
Becomes very white if he happens to land
On sun-faded rocks, and surprisingly brown
If near some dark object he quickly plumps down.
His diet consists of a number of ants,
Of beetles and flies, and if given a chance
He also eats worms. His triangular head
Is useful in digging him into his bed
Of loose sand and gravel. A flip of his tail
Completes the performance, and enemies fail
To ferret him out. When confronting a foe
He lowers his head and receives any blow
On his terrible horns, while the scales on his back

Stand stiffly upright to ward off the attack.
From late in November till spring rolls around
The horned toad sleeps blissfully, deep in the
 ground.

The annual Coalinga Horned Toad Derby takes place each Memorial Day weekend in California. Coalinga, with a population of under ten thousand souls, forms a southern-facing triangle with the Pinnacles National Monument and the city of Fresno. The first recorded horned toad races actually took place on the other side of the country when, according to a 1934 United Press wire story, a twenty-five foot circular track was erected at the Miami Biltmore Country Club for the occasion. But Coalinga, in the native range of the coast horned lizard, and with four other species within a fifty-mile radius, was a more seemly place for the derby.

The Coalinga American Legion Post no. 2 staged a Third Annual Horned Toad Derby in 1935, preempting both the first and second annual events. This innovative fund-raiser for the Boy Scout program developed from a successful ad hoc event two years earlier when the Chamber of Commerce and the Junior Chamber held their joint banquet at the Coalinga Mineral Springs Hotel and cleared the ballroom floor for abundant creek frogs to take the spotlight. In 1937 the Coalinga Chamber of Commerce formalized the annual happening, banishing other racing reptiles and mice from the program.

To establish their regional fame and prevent the idea from being stolen, the California Horned Toad Derby Racing Association was incorporated in 1938 by the Chamber's executive secretary, and the high school students adopted the creature as their mascot. Over the years supplementary events have been added, including a parade complete with Derby queen, a livestock auction, coloring contest, extra races, and, most recently, a chili cook-off.

A *trompe l'oeil* that probably originated as a 1930s postcard in
El Paso, Texas. More recently it has captivated participants at the
annual Horned Lizard Derby in Coalinga, California.

While no one bucks the idea of entertainment, the new
mood favors respect for the environment. The Horned Liz-
ard Conservation Society was organized in Austin, Texas, in
1990, and is dedicated to taking responsibility for helping
Phrynosoma survive. As members joined from other states, a
lively newsletter appeared with legal, scientific, folkloric, and
even historical information about horned lizards, with a page
of letters, many from environmentally aware children. The
Society's education committee has developed a curriculum
unit for elementary school science classes to keep alive inter-
est in horned lizards.

Mexico

*T*he native culture of the Southwest received scant notice from Europeans, other than the Spanish, until westward expansion across the United States in the nineteenth century excited the attention of travelers and scientists crossing the Great Plains, the Rocky Mountains, and the deserts. They described the people they encountered as curiosities rather than fellow human beings and wrote enthusiastically about their surroundings. Only the inability to understand another language prevented their recognizing many indigenous specimens that had long since been described and classified in Mexico. A succession of Spanish kings dispatched missions to take a full accounting of their distant possessions, detailing the natural history no less than the sources of mineral wealth.

The *Nova Historia Plantarum, Animalium et Mineralium Mexicanorum*, a report on the first scientific expedition under royal aegis, was published in Rome in 1651. The author, Francisco Hernández, described a creature he assumed belonged to the lizard family, a small animal with a flattened and almost circular cartilaginous body marked with many colors. He noted that it was always cold to the touch, slow moving, and bristling with spikes set in its head like a crown. Moreover, it seemed to enjoy being held in the hand, earning a reputation as a friend of people. "One extraordinary thing that exists in no other animal (as far as I know)," he wrote, "is that if its head or eyes are pressed, or if it is struck carelessly, it vigorously shoots drops of blood . . . up to a distance of three paces." More extraordinary from our perspective was the reputed medicinal property. "When baked and pulverized, a drachm may be added to wine and water to effect a cure for syphilis and the pain it causes."

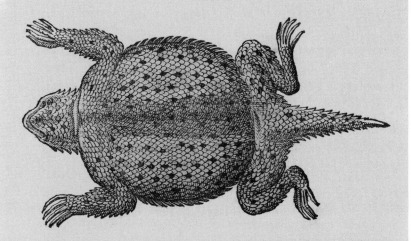

328 RERVM MEDICARVM NO. HISP.

nus forma , ni longè minor eſſet, nec vncias quatuor , longitudine aut la-
titudine,æquans . cartilagineum autem eſt, & multis variatum coloribus ,
gelidum ſemper tactu repertum , tardi inceſſus, ac rarò mutans locum
etiam contrectatum , atque apprehenſum . Sed caput eſt duriſſimum , &

An elegant rendition of a horned lizard dating back to 1651.
The drawing appeared in Francisco Hernández' *Nova Historia
Plantarum, Animalium et Mineralium Mexicanorum*, the first
Mexican animal, vegetable, and mineral compendium produced
for the royal court of Spain.

A Mexican cleric, Abbé D. Francesco Saverio Clavigero, also expressed an interest in horned lizards. The Jesuit son of Spanish immigrants, he was expelled from the country in 1767 and settled in Italy, where he completed a two-volume illustrated history of Mexico. He mentioned that there were many small lizards, though just one of them, which he termed *Tapayaxin*, he deemed worthy of notice. He, too, described the blood-squirting and other now familiar characteristics, and suggested that "it would seem as if, being of so cold a constitution, it received some comfort from the heat of the hand."

In 1786 the Spanish King Carlos III authorized a Royal Botanical Expedition to New Spain. A Spaniard, Martín de Sessé y Lacasta, led the expedition and was credited with initiating the venture. José Mariano Mociño, a few years his junior, served as the principal botanist. During the sixteen years of the expedition, the parties combed not only Mexico but also the Caribbean, northern Central America, California, and all the way north up to Vancouver Island. From time to time José Longinos Martínez, who was responsible for most of the zoological efforts, traveled independently to the Pacific Coast and into Baja California. Their extensive collections formed the nucleus for the National Museum of Natural History of Mexico. After he returned to Spain, Mociño worked for several years on the collections and illustrations and commissioned copies of many of the drawings and paintings. The major publications, although completed, were not published until almost a century after the expedition ended, by which time the original two thousand illustrations had disappeared. The wealthy Torner family of Barcelona had purchased them in 1820, and somehow they had been forgotten. Recently the entire portfolio came to light, and now belongs to the Hunt Collection of Botanical Documentation at Carnegie-Mellon University in Pittsburgh. The majority of the representations depict botanical

The Abbé D. Francesco Saverio Clavigero completed his *History of Mexico* when exiled in Italy. His illustrations of exotic fauna included the horned lizard (top right).

specimens, but about two hundred are of animals. Seven of these are reptiles, including two horned lizards. One plate, the colors still unfaded, displays the dorsal and ventral view of an unidentifiable species. Probably it is a composite of more than one species, or else drawn from memory. The second, a splendid ink drawing, shows the dorsal view of a *P. asio*.

As scientists and surveyors set to work in the western United States, an ambitious young German naturalist, a graduate of the University of Leipzig, traveled to Mexico to undertake the *Herpetologia Mexicana, seu descriptio amphiborum Novae Hispaniae*. Arend Fridericus Augustus Wiegmann published the first volume in Berlin in 1834, but his untimely death precluded the work's completion. He is remembered, however, for several achievements, including naming the genus *Phrynosoma*.

All the endemic species in Mexico occur south of the Tropic of Cancer. In the southern part of the country there is a fine assortment, so many indeed that scientists have expressed concern over the veracity, or at least accuracy, of observers. This southern selection includes *P. boucardi, P. orbiculare, P. asio, P. taurus,* and *P. braconnieri*. Mostly confined to the deciduous and pine forests on the highland fringe of the Mexican Plateau, *P. orbiculare* comes as far north as Durango. *P. taurus* typically inhabits the semiarid basins on the southern stretches of the plateau, and may be the species that earned the lizard's affectionate nickname in Mexico, *torito de la Virgen*. *Phrynosoma asio*, the largest species, ranges farthest south into the state of Tehuantepec and, some assert, Guatemala. All seven species of horned lizard found in the United States occur in northern Mexico, and Mexico actually surpasses the United States in its diversity of *Phrynosoma*.

In his journals, Henri Joutel, a historian for Robert Sieur de la Salle, who established the first European colony in Texas

in 1685, mentioned the horned lizard, though he did not venture to name the alien creature. When one of the surgeons in the community was hunting for turtles in the holes that pocked the fields, he was bitten on the arm and suffered grave injury. "We didn't know if it had been a snake which had bitten him, or some other animal, because I had seen certain animals made almost like a toad, having four feet and the mouth nearly the same, but the skin on their backs is raised up into hard bumps and they have a little tail; but they don't jump, they walk."

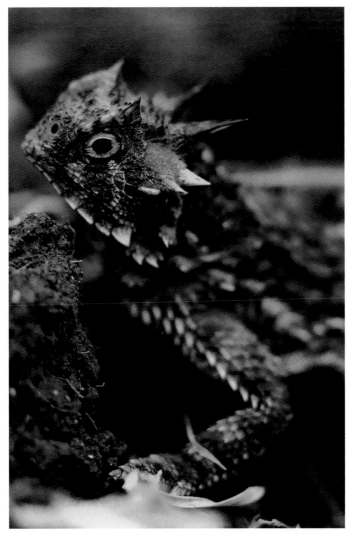

Close-up portrait of a Texas horned lizard. PAUL M. MONTGOMERY

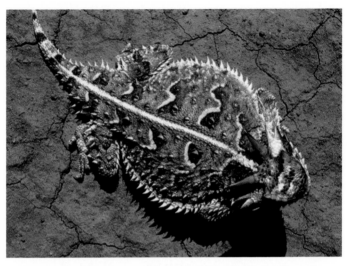

An overhead shot reveals the horned lizard's distinctive scale patterns. WYMAN MEINZER

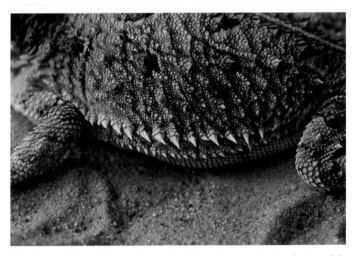

The horned lizard blends deceptively into the sand; only the "teeth" offer warning to predators. WYMAN MEINZER

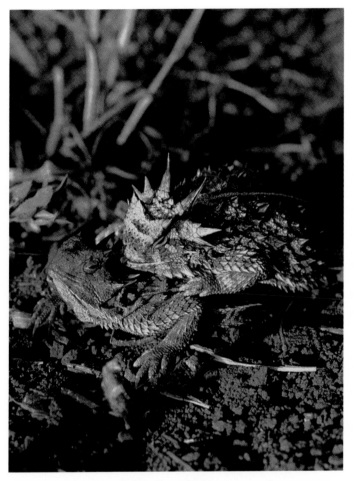

Lizards mate unhurriedly, and with apparent pleasure.
WYMAN MEINZER

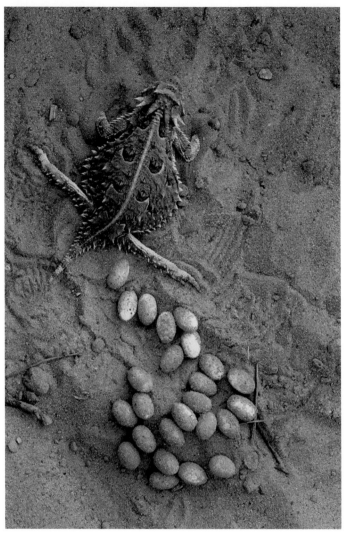

After laying her clutch of eggs, the horned Lizard's maternal instinct and attention are at an end. WYMAN MEINZER

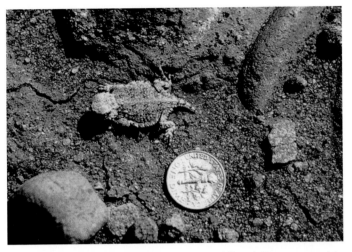

The vulnerability of a newborn coast horned lizard (*P. coronatum*) is emphasized when seen beside a U.S. dime. LESTER MILROY

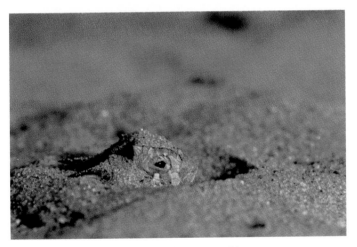

Half-hidden, the horned lizard is inscrutable. WYMAN MEINZER

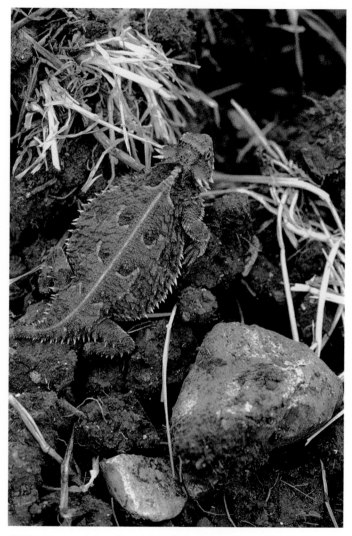

Different vegetation demands different camouflage, in this instance a muted gray. PAUL M. MONTGOMERY

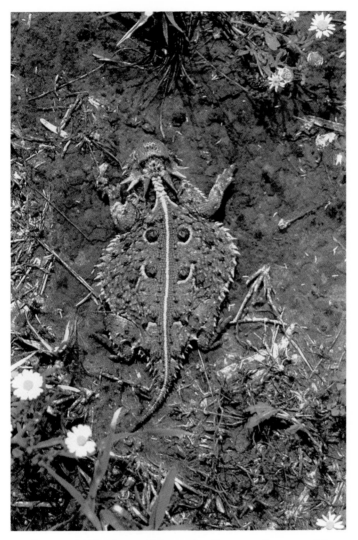

A more vivid background demands adjustment for successful
protection from predators.
TEXAS PARKS AND WILDLIFE DEPARTMENT

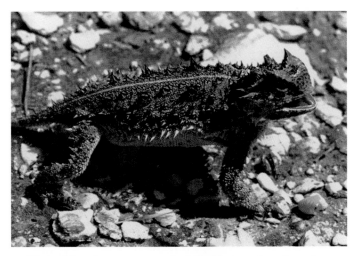

Horned lizards can appear quite intimidating when they take a defensive stand. PAUL M. MONTGOMERY

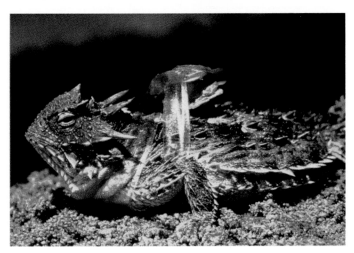

Small radio transmitters, set in backpacks, keep track of individual *P. coronatum* in population surveys. LESTER MILROY

Modern History

When the Louisiana Purchase was made in 1803, President Thomas Jefferson recognized the extensive territory as a forerunner of space to come and set in motion preparations for the first overland expedition to the Pacific. He hoped a well-trained force would find the elusive Northwest Passage, a riverine path to bring trade with the Orient within easier reach. He procured $2,500 from Congress for the eight-thousand-mile excursion, and invited Captain Meriwether Lewis, the son of longtime family friends and for two years his secretary, to lead the expeditionary party. Lewis, a fellow Virginian who had grown up with a love of the wilderness and skill as a hunter, was sent to Philadelphia for instruction in botany, zoology, and celestial navigation. He requested that Lieutenant William Clark, with whom he had served in the army, lead alongside him. About forty men ranging from twenty-nine to thirty-three years of age were assembled, in part for the particular skills the trip would demand on top of the customary needs of the day, like boat repair, carpentry, and Indian sign language.

The group wintered in St. Louis, then set off in three boats along the Missouri River in May 1804. By the time they returned in 1806, as every American schoolchild is taught, they had wintered in present-day North Dakota, traveled on into Montana, ridden horses over the Continental Divide, and made their way to the headwaters of the Clearwater River. They then canoed to the mouth of the Columbia River and wintered on the inhospitable coast before tackling the long journey home.

Given the complexity and diversity of tasks, and seeing the variety of creatures that were to be hunted or avoided, Lewis wrote in great detail about *Phrynosoma douglasii*. His

account questioned the French name for the small animal, "prairie buffalo," presumably a tongue-in-cheek nickname for the lizard's horns and defensive back-humping, which caused it to resemble a miniature bison.

He wrote about "a speceis of Lizzard . . . native of these plains as well as of those of the Missouri. I have called them the horned Lizzard. [T]hey are about the same size and a good deel of the figure of the common black lizzard. [B]ut their bellies are broader, tail shorter and their action much slower; they crawl much like the toad. [T]hey are of a brown colour with yellowish and yellowish brown spots. [I]t is covered with minute scales intermixed with little horny prosesses like blont prickles on the upper surface of the body. The belly and throat is more like the frog and are of a light yellowish and brown color. [A]rround the edge of the belley is regularly set with little horney projections which give to these edges a serate figure. [T]he eye is small and of a dark colour. [A]bove and behind the eyes there are several projections of the bone which being armed at their extremities with a firm black substance has the appearance of horns sprouting out from the head. [T]his part has induced me to distinguish it with the appellation of the horned Lizzard. I cannot conceive how the engages [*sic*] ever assimilated this animal with the buffaloe for there is not greater analogy than between the horse and the frog. This animal is found in greatest numbers in the sandy open parts of the plains, and appear in great abundance after a shower of rain; they are sometimes found basking in the sunshine but conceal themselves in little holes in the earth much the greater proportion of their time. [T]hey are numerous about the falls of the Missouri and in the plains through which we past lately above the Wallahwallahs."

Within a few weeks of the expedition's launching, Thomas Jefferson sent a horned lizard to Philadelphia, to the por-

trait painter Charles Willson Peale, who had tried to better his fortunes by organizing the country's first natural history museum. (Peale's son, the artist and naturalist Titian Ramsey Peale, was meantime accompanying Lewis and Clark.) The lizard was the first of the "nondescripts" Jefferson donated to the museum. Peale replied, "I am greatly obliged to you for the curious Lizard of Louisiana, which it certainly is, and not a toad. It shall not be exhibited untill [*sic*] the Osage Indians are on their return. I have not yet had time to examine the Authors to know if it has ever been described; if not, I mean to give a drawing of it to the Philosophical Society." This he did.

A few years later Major H. Stephen Long of the United States Topographical Engineers, who had taught at West Point, was asked by John C. Calhoun, the Secretary of War, to assume command of an expedition to explore the region between the Mississippi River and the Rocky Mountains. Having already traveled extensively between the Arkansas and Red Rivers, Long assembled a party. They were to acquire as accurate and thorough knowledge as practicable, as the country was "daily becoming more interesting." They were bound also to conciliate the Indians by kindness and presents as they made their way from Pittsburgh to the mountains. An account of their journey was published in London in 1823. Long spotted many "orbicular lizards," and was perhaps the first in North America to notice more than a single species, "differing from each other in the length of the spines and position of the nostrils."

Not all travel was under government or military auspices. As reports filtered back from the West of the wonders to be seen, the adventurous found reasons or excuses to explore their country. The possibility of new trading opportunities was not overlooked. Josiah Gregg's long years of travel across the prairies were prompted by doctor's orders. For some

months prior to his departure he suffered what he termed "a complication of chronic diseases" that no friends in their sagacity or science could remedy. Barely able to walk around his room, he heeded his physician's advice to take a trip across the prairies in the belief that a change of air and habits might do the trick.

In 1831 Gregg set off with a spring caravan to Santa Fe, and spent most of the next several years as a trader in what was then northern Mexico, crossing the prairies over and again. His journal, vivid and captivating, describes travel difficulties, encounters with Indians, and accounts of animals, including sheep that provided inferior wool but satisfying mutton. Among undomesticated fauna, he commented on black bears and grizzlies, the gray wolf, bighorn, *paisano*, honey bees, black-tailed deer, and "the horned frog . . . the most famed and curious reptile of the plains. Like the prairie dog, it is only found in the dry regions, often many miles from water. It no doubt lives nearly, if not wholly, without drink. Its food probably consists chiefly of ants and other insects; though many Mexicans will have it, that the *camaleón vive del aire*—lives upon the air."

He confessed, "I once took a pair of them upon the far-western plains, which I shut up in a box and carried to one of the eastern cities, where they were kept for several months before they died,—without having taken food or water, though repeatedly offered them. . . . It is a very inoffensive creature, and may be handled with perfect impunity, notwithstanding its uncouth appearance, and sometimes vicious demonstrations."

The humble creature, being so easily carried and kept, earned a reputation. Maximilian, Prince of Wied-Neuwied in Prussia, forsaking his soldiering pursuits, retrieved a love of nature instilled long before by his mother. As he entered his fiftieth year he ventured on a lengthy trans-Mississippi trip, which he recorded in three volumes. He met with Indi-

ans and fur trappers and all manner of wondrous sites. But he searched in vain for the horned lizard, which he had heard abounded at Yellowstone and at Fort Union.

Surveyors, soldiers, and travelers alike jotted down descriptions of their sightings, choosing words that made the lizard seem as intriguing as Dr. Doolittle's two-headed wonder, the Pushmi-Pullyu. One young soldier and his military party crossed the Neosho River while surveying the southern boundary of Kansas where, he recollected, "We saw a curious specimen of frog . . . horns all over its body and two tolerably long ones on the forehead. Its size is that of a common frog, but it has more the look of a pet animal than [of] one of the detested animals of the species to which it belongs."

In the 1840s one of the soldiers under the command of Colonel Stephen W. Kearny and Colonel Alexander W. Doniphan noted an observation made as they crossed the Arkansas River on their way to Santa Fe: "two specimens of the horned frog, or lizard, a curious and rough-looking animal, harmless but disgusting in its appearance. All over their bodies they have little short horns or what looks like them, for they seem not to be a bony substance but [a] kind of gristle, which has caused the name. They are probably of the chameleon species, as they have the color of the soil on which they are found, which, of course, varies."

Once the creature's harmlessness was confirmed, it became a wonderful resource for practical jokers. An 1853 issue of the *Spirit of the Times* boasted that not only was the native fauna of Texas the best in the country, but "in horned frogs, scorpions, tarantulas, and centipedes, we beat the universe." Should anyone need reminding, the article explained, horned "frogs" could be seen in jars in the windows of apothecaries, on sale by young boys who stood about with them on the levee at New Orleans, or "neatly soldered up in soda boxes, and mailed by young gentlemen in Texas, to fair ones

in the Old States." When the fair ones received the neat package from the post office they were delighted with the prospect of a daguerreotype, or perhaps jewelry. However, when they opened the package, they fainted as the lizard hopped out in excellent health.

The writer related that "a horned frog is, simply, a very harmless frog, with very portentous horns; it has horns because everything in its region—trees, shrubs, grass even has thorns,—and nature makes it in keeping with all around it."

In 1852, when Frederic Law Olmsted left his Staten Island farm seeking to settle in a more favorable climate in hopes of prolonging the life of his tubercular brother, he journeyed through Texas. The account of his four-month trip through the former Republic, recently included in the Union, became a classic. He described the venomous insects that outsiders dreaded, and provided antidotes for their bites and stings. The horned lizard must have supplied welcome relief, and he mailed a couple back home, which produced the same kind of shock experienced by the young ladies anticipating gifts from their sweethearts. Unafraid, because "its eyes are gentle, its movements active, and its whole expression is not repulsive," he sent two specimens in a little pasteboard box from San Antonio to New York, but the box arrived before the letter and, being found to contain eccentric tropical reptiles, caused some "explosive consternation." The recipients opened the box with tongs. After the letter arrived announcing the "innocent nature of the visitors," they became household pets. As they soon grew thin indoors, their legs were tethered with cotton twine and they were left to their own resources in the grass, where they recovered their corpulence.

The city of Galveston, Texas, was a key point of entry into the state in the nineteenth century, before a combination of natural disasters and the growth of Houston eroded its popularity. As in all port cities, any number of opportun-

ists existed along the waterfront with their wares. The horned lizard was small and harmless enough to be carried easily, and frivolous enough in appearance to attract customers. William Kennedy, who served as the British consul in Galveston for several years, recalled in his memoirs that he had been offered some for ten dollars apiece by a sailor who kept them in the crown of his hat. John Duval, whose *Early Times in Texas* attracted readers preferring to travel vicariously, was less enthusiastic. Panicking, lest he be assaulted by something as venomous as a centipede or tarantula, he attacked the first horned lizard he saw by picking up a stick about ten feet long and hitting the poor innocent until it was flat as a pancake.

Francis Sheridan, grandson of the Irish politician and playwright Richard Brinsley Sheridan, spent a few months on Galveston Island in 1839, after serving as a British diplomat in Barbados. He found horned lizards perfectly fascinating, "tail & all about 6 inches long having the head of a frog, the back & belly of an alligator, & the tail of a turtle." He set up home for a pair of them in a cigar box, and cut narrow windows mindful of Gothic architecture. Although assured they needed little to eat, he pampered them with a diet of his own choosing, in order to assure that they reached a good old age (which, sadly, he himself did not). "Their rations in the cold season when flies are scarce," he wrote, "are 3 blue-bottles per diem." On one occasion, when only a single insect could be found, he executed "the judgment of Solomon," dividing it between the two lizards. "Frequently I am enabled to afford the luxury of a musquito [*sic*]," he confided, "which serves as a variety to their frugal meal."

Thomas Jefferson sent a variety of animal and bird specimens to Peale's museum in the early years of its existence, perhaps recognizing the important role natural history museums could play in developing public awareness of the natural

world. Such museums became the "storefronts" of scientific research and classification rather than places of wonder established to titillate the public or, earlier still, demonstrate the owner's wealth and eclecticism.

Before the century reached the midway point, Peale's exhibits were being removed from their literal or figurative pedestals and mostly taken to the new Peabody Museum. In Washington, the Smithsonian Institution was established in 1846. Herpetologists played an early role in developing the collections. Spencer Fuller Baird, among the first members, was asked to build up the Institution's natural history section. The fruits of his own excursions, together with the specimens gleaned on the recent Wilkes Expedition, formed the basis of the Institution's collection.

At least two of Baird's protégés worked with horned lizards. His French-born assistant, Charles Girard, found the type species of *P. douglasii ornatissimum* while on the expedition led and described by Captain Howard Stansbury in his *Exploration and Survey of the Valley of the Great Salt Lake of Utah*. Girard wrote a monographic essay on *Phrynosoma* in an appendix to this account. Besides its value in sharing scientific knowledge on the lizards acquired to this date, the early 1850s, the quality of the lithographic illustrations is remarkable even today.

Edward D. Cope, another of Baird's students, published his first scientific paper at the age of nineteen, but "abhorred routine and only accepted a university professorship when he could no longer support himself through private means." He became a dominant figure in American zoology, influencing his generation with research not only in North America, but also internationally, in anatomy, paleontology, and biology. His name on early *Phrynosoma* specimens that grace museum collections attests to his participation in western surveys during the 1870s. He described innumerable new genera and species in more than 1,400 published works,

but his enthusiasm and volatility earned him the reputation of being erratic and inattentive to detail. Nonetheless, the scientific journal *Copeia*, which deals with lower vertebrates, was named in his honor.

Once the great age of surveys was past, herpetologists spent more time in the western states, and their research started to merge with the existing work carried out by earlier and contemporary scientists on the Mexican side of the border. The horned lizard continued to intrigue. As well as the acclaim he achieved as a scientist, carrying out exemplary research on *Phrynosoma* and other reptiles, Harold C. Bryant was remembered affectionately in California and beyond for the page among his graduate notes that folded out to four feet in length and showed the pattern of a bloodsquirt!

In Texas, John Strecker bridged the change of centuries from his headquarters at Baylor University in Waco. He carried out energetic sorties in the field, and wrote extensively about reptiles, showing a partiality for horned lizards in the central and far western parts of the state. Baylor immortalized its favorite son by naming a museum for him on the campus. However, Strecker's popularity extended beyond the bounds of natural science. As a folklorist, he gathered Texas superstitions and anecdotes, including numerous horned lizard tales.

Cartoon by Rowland Emett, "Texas—a travelling Technical Man,
who uses a horned toad for wild-catting and locating wells," first
published in Willis W. Pratt's essay, "Americans at Home, the British
Cartoonist's View," in *Texas Quarterly*, Winter 1960, Vol. III,
No. 4. Used by permission.

Extended Range

The old adage "beauty is in the eyes of the beholder" hardly explains the fascination for horned lizards that reaches thousands of miles beyond their native range. Perhaps the French term *joli laid* is more appropriate, for while they are unsightly and ungainly creatures, they are beguilingly photogenic. The mystique created by fierce and even menacing facial expressions, so at odds with their mild temperament, may also explain why, dead or alive, they have charmed travelers and collectors for so many centuries. Several species are exhibited in European natural history museums, and those reserved for research lie quietly on dusty shelves, catalogued, stuffed, or embalmed. Alive, they have unwittingly served various needs or purposes in the eastern states and abroad. They have been dispatched long distances as a means of pest control, as pets, and as a challenge for herpetologists eager to breed exotic species. In the bad old days, thousands upon thousands were collected, killed, and sold for the curio trade.

The British Museum described its acquisitions years before the genus received its Latin name, but well after Spain had received specimens from Mexico. The port of Rotterdam took in fauna from distant colonies of the empire, but its horned lizards came from the United States when a Dutch-born scientist, Gerhard Troost, whose youthful wanderlust was subsequently replaced by almost fanatical collecting, sent them in the late 1820s. Troost, a mineralogist with a professional interest in pharmaceuticals, had been commissioned by King Louis Napoleon to undertake a venture in Java. However, when the monarch relinquished the throne of Holland, Troost sailed to Philadelphia. In 1812 he became a founder and first president of the Philadelphia Academy of

Sciences, and, as a man of many interests and skills, established a laboratory to manufacture drugs and chemical preparations and set up a private natural history museum. Years later he embarked on a new career. He was appointed professor of geology and mineralogy at the University of Nashville (now Vanderbilt University) and later was appointed the first state geologist of Tennessee. Although he sent the small reptiles to the Netherlands from Tennessee, he most likely acquired them in Philadelphia from a member of Major Long's expeditionary force that covered the ground from Pittsburgh to the Rockies in 1819. His purpose, no doubt, was to enrich the collection of the national museum in his homeland.

At the turn of the century, when requests were received in California for live specimens, they were pleas for help. In 1895 a San Diego newspaper advertisement offered young boys a chance to line their pockets by collecting horned toads. Evidently the Hawaiian government believed the reptiles would put an end to an invasion of Japanese insects destroying crops. The Hawaiians sought five thousand horned toads, for which they would pay a dollar a dozen—good money with so many around for the taking.

The following year the *Tulare Times* in Visalia, a few miles south of Fresno, ran an advertisement on behalf of a professor at the University of Bogotá in Colombia. He wanted the lizards to destroy insects deemed injurious to vegetation, though the grounds on which he based this hope have slipped from memory. Regrettably, he had not done his homework adequately. A government agricultural report later reported that the lizards had died within months of arrival either from the climate, from homesickness, or because the enemy had turned out stronger than expected. Once expired, they were preserved in alcohol on the shelves of the National Museum of Bogotá. Apparently undeterred by this failure, Guatemalans ordered a shipment of *Phryno-*

soma soon afterward to combat a pest that was threatening their coffee crop.

The same hope may have led grove owners in Florida to purchase horned lizards as general factotums to hold the insect pest population in check. Although this was long ago, the creatures are still scattered around the state, making unexpected appearances from time to time. Reports of sightings around Greater Miami have ceased, but people living there in the 1930s often caught a glimpse of the lizards on sandy lots, and four adult specimens were presented to the city's Tropical Biological Society in 1934. Soon after World War II they were quite common in the high sandhills of Fort George Island in the extreme northeastern part of the state, though no one has any idea how they came to be there. Several were picked up in the early 1950s in and around Leesburg, northwest of Orlando, and Belleview, a little further to the northwest, where turkey oak and longleaf pine alternate with rosemary scrub on the rolling sand hills. In 1953 a single lizard was spotted in coastal Indian River County, just south of the Pelican Island Wildlife Refuge, and several others in Polk County, due east of Tampa.

In neighboring South Carolina, *Phrynosoma cornutum* live in a number of communities in the Charleston area. They were probably introduced in the early years of this century to Fort Moultrie, in Charleston Harbor, the site of a valiant defense by colonists during the Revolutionary War. A former curator of the Charleston museum attributed their presence to the legacy of soldiers serving in the area in the 1920s, though others argue it was a generation later. Whichever may be the case, horned lizards established a sturdy population at the fort and even ventured to the Isle of Palms, over the bridge that straddles the narrow inlet separating the two places, where they survived the wrath of Hurricane Hugo. Others staked their claim on Edisto Beach, south of the city, and in Garden City on the north side, also settling around

Myrtle Beach, one of the state's favorite resorts. They are seen occasionally on James Island and elsewhere in the neighboring low country.

By 1952 the Charleston zoo boasted two *Phrynosoma* and people had begun to pick them up and keep them as pets. The story of a schoolteacher receiving a hundred lizards after begging her uncle in Texas to send her some is looked upon as folklore rather than fact. But Texas has often been the source of exports. Knowing that they have never made very satisfactory captives, one Louisiana resident found comfort, during the last months of the Great War, by liberating a *P. cornutum* he had brought from central Texas on a high sandy hill near his home in Forbing, just over the state border.

Live horned lizards crossed the Atlantic a little later. At least one German herpetologist has recorded how he kept the creatures alive for up to three years during the 1930s. By the 1950s they were to be found once in a while in pet stores, certainly in the Netherlands and reputedly in Germany, England, and France as well. Catalogs began to list their availability, and one longtime breeder recollects buying them as a youngster in Switzerland and managing to keep a Texas horned lizard alive for eighteen months despite his ignorance about the need for hibernation and ants. He became enlightened by an impressive picture of the Mojave Desert blanketed with snow, and thereupon placed them in the refrigerator for two to three winter months. That did the trick, and enabled a pair of desert horned lizards to mate and produce healthy offspring when spring arrived. They passed the warmer months in an outdoor terrarium, thriving on ants and plentiful attention. As an adult expert, the naturalist has bettered his skills as reptile breeder, boasting amazing longevity for the lizards in his care, including a seventeen-year-old *P. mcallii*.

Neither pet shops, pest destroyers, museum specimens,

nor travelers' souvenirs have matched the quantity of horned
lizards that sadly found their way into curio shops, especially
in California. In an age when our tendency is to lay blame
on "society" or an anonymous villain, it is remarkable to
learn that one man was held responsible for the near demise
of a whole species in southern California toward the end of
the nineteenth century. His treachery was not at the time
recognized as such, and no doubt his efforts brought plea-
sure to innumerable youngsters and adults alike who were
delighted to receive horned lizards as gifts.

William Blakely had studied taxidermy before he went
into the housewares and ironmongery business in Pasadena
in 1881. Proud of his skill, he enjoyed displaying his handi-
work in the store window, and within a few years realized he
was doing a better trade in horned toads than hardware.
Accordingly, he started to advertise for more of the raw
material, as it were.

"Boys now is your chance!" he proclaimed, offering five
cents apiece, a princely sum, to meet his needs. Once he
received the bounty, the lizards were put in a jar and chloro-
formed for about fifteen minutes. As soon as they were out
of their misery, Mr. Blakely started to work with a sharp
knife, slitting their underbellies, cleaning them out caringly
with an arsenic preparation, then stuffing the small torsos
with sawdust, and the tiny limbs and tails with cotton. Pa-
tiently, he allowed them to cure for two months before put-
ting them on sale.

Some he posed on pasteboard boxes that retailed for fifty
cents. Others he set on a more attractive eight-inch orange-
wood plinth. The most extravagant gift offered to his cus-
tomers was a small zoo collection, which included, in addi-
tion to the horned lizards, stuffed centipedes, tarantulas,
and scorpions.

With the sweet smell of success overpowering the aroma
of embalming fluid, he turned his attention full time to the

curio trade, hiring a dozen or more full-time workers to prepare horned lizards, other small vertebrates, and various desert plants for sale in his new natural history store. Once the retail end of the business lost its appeal, he continued to collect commercially until his retirement in 1917 at the age of sixty. Mostly he collected *P. coronatum blainvilli* in and around Pasadena. As winter tourism grew, so did the traffic in curios. The New Year's Day Tournament of Roses Parade was a high point of the season that developed from about the 1890s, around the same time people were beginning to express concern about the depletion of wildlife in the surrounding communities and countryside. As the local supply became harder to find, Blakely's collecting territory was expanded throughout the Los Angeles Basin to include *P. platyrhinos* specimens from the Mojave Desert.

His "hunters" needed to spend only one month each year scouring the area, securing twenty-five to thirty lizards a day, to bring in up to eight thousand a year. The traffic continued until a law went into effect prohibiting their sale in the 1930s, by which time a total of at least 115,000 lizards had been exterminated.

Although California succeeded in calling a halt, other states took their time. In 1941 the New Mexico legislature passed its first reptile protection law to save horned toads in the Albuquerque area. It became unlawful to kill the lizards, less out of sensitivity toward the victims than because their hearty appetite reduced the ants and other insects that threatened the state's agriculture. Curio dealers suffered, and for a while experimented with replacing the real thing with plaster of Paris models.

Even this measure did not conclusively end the traffic. Long after, live horned lizards continued to provide a profitable market for young West Texans. One erstwhile collector remembers, with at least a semblance of contrition, how he responded to advertisements in a Topeka magazine

that paid a nickel for the big ones and three cents each for the babies, which tended to expire on the journey. They were simply picked up, pocketed, then sent through the mail in a shoebox with a few air holes punched in the sides. Once, back at the turn of the century, the postal service balked at condoning this cruelty, refusing to carry the boxes filled with quaking lizards and their temporary diet of dead flies. But as the mail service expanded and the volume increased, the clumsy packages of small boys trying to supplement their weekly allowances escaped attention.

The lizards provided excellent barter, too. One former Boy Scout recalled his delight in the 1950s when he attended a jamboree in Pennsylvania and came home with a Hawaiian lei, an American Indian headdress, and a splendid bullwhip, all exchanged for common or garden Abilene horny toads.

In 1993 the Texas House and Senate adopted the following resolution:

WHEREAS, The State of Texas traditionally has recognized certain natural life forms commonly found within the state as tangible representations of both the state's proud spirit and its vast and diverse natural heritage by proclaiming them official state symbols; and

WHEREAS, The Texas horned lizard, *Phrynosoma cornutum*, is well known and much loved by its human neighbors in the hot, arid regions where it makes its home; and

WHEREAS, Known variously as a horned toad, horny toad, and horned frog, this fascinating creature nevertheless is a true lizard, a member of the reptile suborder Lacertilia, with a lineage that has been traced back to the dinosaurs; and

WHEREAS, The horned lizard possesses numerous attributes that qualify it for designation as an official representative of our state; despite a spiny exterior that

presents a forbidding appearance, it is at heart a docile and peaceful creature; and

WHEREAS, A skilled hunter, the horned lizard helps to diminish the population of a variety of insect pests; although it prefers a diet of ants, it will also eat grasshoppers, crickets, beetles, pill bugs, and spiders; and

WHEREAS, Its protective coloration and resourcefulness enable it to escape detection by predators, but when threatened it is able to inflate its body to frighten its adversaries; and

WHEREAS, Although these characteristics distinguish the horned lizard as a fitting embodiment of our state and its heritage, it is perhaps most appropriate for designation as an official state symbol because, like many other things truly Texan, it is a threatened species; now, therefore, be it

RESOLVED, That the 73rd Legislature of the State of Texas hereby recognize the Texas horned lizard as an appropriate representative of our state; and, be it further

RESOLVED, That the Texas horned lizard be officially designated the State Reptile of Texas.

One by one the states are heeding the plight of the horned lizard. Wyoming has now adopted the short-horned lizard (*P. douglasii*) as its state reptile and there is concerted effort to better protect populations.

Conservation

*R*ecently the horned lizard has become a player in the conservation movement. Lacking the stature of the spotted owl, the golden-cheeked warbler, and other politically sensitive characters, the lizard is nonetheless attracting scientific and civic attention. Researchers are keen to determine if populations are dwindling, disappearing, or merely taking up new residence, and the public-spirited are concerned about threats to the lizard's native habitat. When an airline commercial featured a small child carrying a pet horned lizard on board (remembered by viewers as a Texas horned lizard), a minor outcry ensued. Texas designates both the Texas horned lizard and the mountain short-horned lizard as threatened, while the third native Texas species, the round-tailed horned lizard, is not protected. The commercial was dropped—with apologies.

Seemingly, where once *Phrynosoma* abounded, they have now become scarce, if seen at all. In places where they were once part of the natural scene, they are gone. No massive destruction, deliberate or inadvertent, has removed them, and skeptics think the figures bandied about referring to their past presence may be overestimated. One eminent herpetologist believes that because they are long-lived, people saw the same few over and over for a decade, and erroneously multiplied the numbers in any given area, such as a backyard or neighborhood field.

Even with this in mind, horned toads are on the decrease and need our help. Professional and amateur conservationists, including educators, children, and dedicated environmentalists, are contributing their efforts. The conservation movement in the United States harks back to the nineteenth century, formalizing awareness of environmental abuse that

leads to species loss. The movement grew in response to a misconception that flourished during the westward expansion across the United States, a belief that the good Lord had placed limitless land at the disposal of humankind. A few individuals, ahead of their time, challenged this naïveté, recognizing the land to be neither boundless nor courting wanton misuse.

Now the movement has become a political tool and a social outlet. Threatened species are perceived as a means of delaying and even halting land development or industrial expansion that impinges on nature. While horned lizards have not yet attracted the same degree of compassion as other species, word is spreading about their less than rosy future. The social wing of environmentalism finds horned lizards appealing. Perhaps the response is due to the horned lizards' wretched looks and helplessness, tweaking a sentimental chord for the golden world of childhood. Or maybe the creatures symbolize the outcome of neglect toward less assertive creatures.

The lizards can combat the treachery of snakes, birds, and a number of mammals. But they cannot hope to fight all the ramifications of urban encroachment, nor hazards like radiation and pesticides. To date no one has ever held up development projects on their behalf, but steps are being taken to put barriers in place should the need arise.

Certain foes were removed decades ago by banishing curio hunters and sellers, and by enacting legislation to prohibit collection. Helpful in their time, these measures do not resolve today's bigger problems. There is still a trade in horned lizards for pet shops, museums, and overseas breeders, although it is carefully monitored by organizations like CITES, the Convention on International Trade in Endangered Species of Wild Fauna and Flora, an international agreement signed in Washington, D.C., in 1973, and which came into force in 1975. More than 120 countries are party to the

convention, the largest wildlife conservation agreement in existence to date. It accords varying degrees of protection, depending on the subject's biological status and the effect international trade has on it. The West Coast *Phrynosoma coronatum blainvillei* was under close watch for some time, then removed from observation after careful review. There is a continuing domestic market for horned lizards, which are collected by the thousands, especially the Texas and San Diego species. Once the lizards have been smuggled out of states in which they are protected, dealers have little reason to fear prosecution. They tend to shrug at the Lacey Act, which makes it illegal to transport illegally obtained wildlife across state lines. Horned lizards do poorly in captivity, and the mortality rate is high in the dealers' overcrowded bins. But profits remain substantial.

Horned lizards are being killed by fire ants and pesticides, radiation, off-road vehicles, agricultural development, habitat fragmentation and isolation, and road and utility construction tied up with the large pockets of urban expansion in regions that the lizards knew were the most pleasant places to live, long before people did.

Fire ants, an introduced predator threatening the lizards, are also part of the larger issue of the effects of chemical pesticides. Better foragers who compete successfully with the lizards for food, imported fire ants are remarkably tenacious, feasting on harvester ants, *Phrynosoma's* dietary mainstay, and other insects. Efforts to halt their march across the country include spraying with a particularly lethal pesticide that biologists claim has virtually exterminated horned lizards in and around Waco in central Texas, either directly or by killing their prey. Others continue to blame the reduction in the area on a hard freeze in 1979, which eliminated both St. Augustine grass and horned lizards.

In 1964 the United States Atomic Energy Commission supported experiments in southern Nevada to determine the

long-term effects of low-level gamma radiation on native desert animals and plants. A twenty-two-acre area was established for researchers to observe and record the breeding patterns of certain reptiles, among them a population of *P. platyrhinos,* the desert horned lizard. The first years of monitoring produced debatable figures, but in 1970 findings showed no reproduction in the fenced area, as a result of female sterility, while numbers had increased in populations outside the confines of the exposed site.

Less dramatically, if only because so few specimens were tagged, horned lizards in California have become victims of off-road vehicular traffic, such as motorcycles, which roar their way by the millions across the desert, unconcerned about anything beneath their wheels. On the highways, the lizards are disposed to stay late on the blacktops, holding on to the last warmth of the day before retreating to their underground sleeping quarters.

Urban development is the principal cause of declining numbers of horned lizards. Housing and commercial properties take over territory formerly swarming with wildlife, and the support systems that sustain human habitation cause equal or greater havoc. Networks of roadways and utility construction, as well as oil, gas, and geothermal leases, are all responsible for the fragmentation of horned lizard populations that leaves small, isolated groups unable to maintain adequate gene pools for their continued existence. Agricultural expansion also affects wildlife habitat, displacing the lizards by new cultivation, or killing them as a side effect of using chemical pesticides for crop protection. When native pasture is overgrazed or converted to cropland, the refuges of lizards and other creatures below the earth's surface are destroyed. Similarly, replacing native vegetation with lawns impedes the lizards' mobility towards an escape route, especially when tough Bermuda and St. Augustine grasses spread a fibrous and impenetrable matting.

Despite the woes, all is not lost. Officialdom and individuals alike play an active role in conservation. In Canada the minuscule populations of *P. douglasii* are listed as "endangered" federally as well as in the Province of Alberta. In the United States several species are afforded state protection, which curbs their decline by collectors, not so much for fear of penalty, as by fostering awareness.

Seemingly, the key to horned lizard survival is monitoring and acting on recorded observations. The conservation of *Phrynosoma* has become a subject of academic study, and the lizards themselves provide opportunities for scientists to experiment with intriguing gadgetry invented for other uses but readily adapted for fieldwork. Studies are being conducted by a number of university and wildlife agencies. For example, one station has put personnel to work digitizing quadrant maps and layering them to identify soil types, vegetation, and harvester ant mounds, and seeing how and where the horned lizards in the region are located.

A certain amount of research is inexpensive. For example, dead lizards have been studied after their removal from bottles of ethanol. The proportion of harvester ant and small beetle remains in their stomachs has been catalogued, and a comparison made of hatchling and adult diet to codify the needs of their descendants. Lizard toe-clippings provide researchers with a tangible item from which they can extract DNA. This enables them to identify the genetic pool of particular lizard populations. Additionally, it allows identification of single individuals, which can be recaptured, and gauges their habitat preferences.

While toe clipping works well for marking all but the smallest horned lizards, individuals cannot be identified again without recapture. A painstaking identification technique used in a research experiment near Palm Desert, California, involves sewing three beads with surgical wire onto the tails of selected lizards in an area to the southwest of the Salton

Sea. These beads enable researchers to re-identify lizards without picking them up.

At the 15,200-acre Chaparral Wildlife Management Area north of Laredo, Texas, biologists are implanting Passive Integrated Transponders (PITs) that look like grains of brown rice into the lizards' abdomens, a procedure accomplished in a few seconds. Each *Phrynosoma* receives a unique nine-digit code number, like Social Security identification. Lizards are read by the same means as a grocery scanner reads prices, and their movements accurately monitored. The system was used originally by veterinarians to keep watch on high-value pets and other valuable animals, and by scientists working with rodents in laboratories. PITs are not radio-active, and there is no risk of internal infection. Tags cost a mere five dollars each, but the scanner price is close to a thousand. Several hundred lizards have been tagged so far in a seven-year experiment that began in 1991, with the assistance of inmates from a nearby prison who hunt for candidates and bring them in for measurement, gender determination, and location documentation.

Also in South Texas and California populations were monitored by a similar high-tech device the size of a fingernail and weighing about three grams. This is an actual radio transmitter and is worn in a handmade backpack that sits between the shoulders of the lizard's front legs. A three-inch wire antenna is used to pick up signals. Tiny batteries last about seven months, until the lizard goes into hibernation. Each transmitter is set on a different frequency and costs slightly under two hundred dollars. Lizards are monitored over their home range, an area of between three and five acres.

The flat-tailed horned lizard exemplifies the struggle for survival, as over a third of its historic habitat in California has been lost, and multiple schemes are likely to remove almost all of the rest. In the Imperial and Coachella Valleys most of the lizard's terrain has been transformed by urban

or agricultural development. About a fourth of the Arizona habitat has gone, and a further third is now threatened by projects that include a large munitions storage facility and the expansion of three communities. These will entail creating additional roads. The flat-tail, *P. mcallii*, now receives special protection prohibiting collection in California and Arizona, as *P. cornutum* does in Texas. Although deemed rare today, the flat-tail was one of the commonest lizards along Highway 78 in East Mesa and Imperial Counties, California, as recently as the 1960s, but no longer, an example of the impact roads have on horned lizard populations.

The fate of the several species of horned lizards is hard to predict, but if human effort is made, they stand a chance. Horned lizards play a role, albeit a humble one, in the ecological system. Their link in the food chain has been challenged by the introduction of the non-native fire ant. These aggressive ants not only kill harvester ants but also promote the use of pesticides, and the pesticides kill even more harvester ants. While the direct effect of pesticides on horned lizards is not fully known, the destruction of their food source obviously threatens their survival. Defense mechanisms that have enabled them to exist until now may not be enough. As humans intrude into their biological niche, only human awareness and effort can save them.

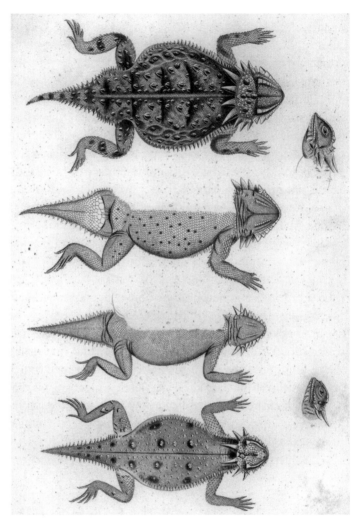

Herpetologist Spencer F. Baird, an early member of the Smithsonian Institution, described horned lizards in the *Report of the United States and Mexican Boundary Survey* published in the 1850s. This lithograph represents different views of *P. solare* (top) and *P. mcallii*, respectively the regal and the flat-tailed horned lizards.

Readings

My favorite childhood toy was a kaleidoscope. Shaped like those delectable Swiss chocolate bars filled with honey and almonds, the kaleidoscope was equally appealing. It held scraps of colored paper that were shaken, held still, and then viewed through a squinting eye, always the same fragments, never quite the same picture. So it has been in this adventure with the horned lizard. Artists, priests, geologists, explorers, zoologists, art historians, soldiers, biologists, folklorists, and poets have all tossed in their scraps of color. And the result is never quite the same.

Besides the carved, painted, and written tributes to *Phrynosoma*, I have heard all too frequently the woeful lament, "They were all over the place when I was a kid, but I haven't seen one for years!" According to current literature, horned lizards in the wild are generally doing quite well. However, they tend to have forsaken cities and suburbs, although an occasional sighting draws newspaper attention.

Horned lizards are still the darlings of scientists. Many journals publish papers every year detailing the authors' particular expertise, whether describing a behavioral trait, a physical characteristic, or an aspect of environmental change. I have read many fine articles and learned commonalities and idiosyncrasies. To retrieve a more holistic image I looked back across the centuries and found a report that may well have been the first written description of *Phrynosoma*. Long before anyone of European or African descent trod a path across the present-day United States, Spaniards were scouring the landscape of Mexico, sending elaborate reports back to their kings. It was tremendously exciting to discover, and hold, a copy of Francisco Hernández' illustrated *Nova Plantarum, Animalium et Mineralium Mexicanorum*, pub-

lished in Rome in 1651, a copy now treasured in the rare books collection of the Nettie Lee Benson library at the University of Texas at Austin. Barely less remarkable, the Abbé Clavigero's *History of Mexico*, published in 1780, carries a synthetic impression of the lizard; maybe the models had escaped the sketcher's eager pen.

American Indians have enjoyed a long understanding with horned lizards, in some cases gracefully described by early anthropologists. Frank Hamilton Cushing's contribution to the *Indian Notes and Monographs* (1920) from the Museum of the American Indian entitled "Zuñi Breadstuff," and Frank Russell's meticulous account of his stay with Pima Indians, which appeared in the *26th Annual Report of the Bureau of American Ethnology*, (Washington, D.C., 1904–1905), give a special insight, and complement the several books by contemporary art historian J. J. Brody.

In the nineteenth century, many ventured out into the western wilderness with notebooks, enthusiasm, and little else to counter the weather and isolation. Intrepid or foolhardy, they wrote copiously, and although horned lizards were never the star attraction, they drew a goodly share of attention. Beginning with the journals of Captain Meriwether Lewis and William Clark, who set out in 1804, I found a variety of delightful accounts, some gathered in multivolumed series like Reuben Thwaites' *Early Western Travels* and Ralph P. Bieber's *Southwest Historical Series*. Other accounts appear in books or papers dedicated to particular missions. Spencer Baird wrote meticulously on reptiles, both for the *Report of the United States and Mexican Boundary Survey* that was presented to the U.S. 34th Congress, and in his section in Howard Stansbury's *Exploration and Survey of the Great Salt Lake of Utah* (New York, 1852).

Several older articles have disarming titles, like O. P. Hay's report in the *Proceedings of the National Museum* in 1893, "On the Ejection of Blood from the Eyes of Horned Toads." Likewise G. A. Boulenger's short piece from the 1916 *Pro-*

ceedings of the Zoological Society of London, "On a New Lizard of the Genus *Phrys.* Recently Living in the Society's Gardens" (which turned out to be rather disappointing). Several included brief notes or letters, like S. Lockwood's "Maternal Anxiety in a Horned Toad," in the *American Naturalist* (17:1883), and Herbert Pack's endearing "Some Habits of the Pygmy Horned Lizard," *Copeia* (63:1918). It is hard to single out a few of today's scientists, but the numerous publications of Eric R. Pianka and Richard R. Montanucci, and Wade C. Sherbrooke's *Horned Lizards: Unique Reptiles of Western North America* (Southwest Parks and Monuments Association, 1981) were all extremely useful. Their authoritative writings do the little lizards proud. From further afield, a number of articles (mostly in German) were kindly sent to me by Bertrand Baur, who lives in Switzerland. A horned toad fan since he was a teenager, he has subsequently become a respected *Phrynosoma* breeder.

It was difficult to find folkloric materials. The Texas Folklore Society publications provided the basis for one chapter, especially contributions by John Kern Strecker of Baylor University in Waco. He crossed academic lines as an equally esteemed biologist and folklorist, and also a splendid writer. I thoroughly enjoyed Mark Jennings' paper, "Impact of the Curio Trade for San Diego Horned Lizards (*Phrynosoma coronatum blainvilli*) in the Los Angeles Basin, California: 1885–1930," *Journal of Herpetology* (21:1987). Besides the paper itself, which was highly entertaining, the references led to all manner of serious and quirky tales, and manifestly proved that scientists tend to have catholic interests and a great sense of humor.

As the horned lizard wends its way into the sciences, folklore, and art, thousands of articles are published as well as references in an eclectic range of books. I have read dozens, perhaps hundreds, and hope that in this short book I have managed to provide an adequate introduction to a beloved and endearing creature of the American Southwest.

Afterword

It was only after the first edition of the book appeared that I learned about Muriel, a pet horned lizard kept by a young Texas Ranger in a short story written by O. Henry. He described her as an "old antediluvian handful of animated carpet-tacks"—not the most poetic words, yet they do have a certain affectionate ring to them.

What is it about horned lizards that produces that nostalgic affection? Why does mention of the little animals produce a faraway look among folk raised in West Texas or the other great empty spaces of the Southwest? Since this book first appeared I have lost count of the number of people who have told me, with a hint of a smile on their lips, how they massacred horned lizards "for the heck of it" or hid them in pencil cases and sneaked them into class. Many others ask me, assuming I know the answer (though no one really does), just where all the horned lizards have gone.

Scholarly treatises have been written about anthropomorphizing animals, often for the benefit of children—endowing them with human behavior and emotions in order to teach a particular lesson. Rabbits are kind, dogs are friendly, songbirds are affectionate and caring. But what desirable human trait is characterized by horned lizards? They are not particularly dedicated parents, and their means of defense, while distinctive and fascinating, are hardly to be emulated. Perhaps they appeal because they serve as a reminder of a golden past, a time without traffic and pollution, crime or violence, a time when the sun shone every day and there were no responsibilities beyond homework.

As well as having a general fascination, the lizards continue to invite scientific research.

While this book has focused only on the seven species that live in the United States and southern Canada, new research is looking at the behavior and biology of the six species that live only south of the Mexican border. The results have confirmed much of the existing information, and as there are still sizable areas untouched by urban development, it is quite possible that more knowledge and understanding will emerge. Meanwhile, several studies have been launched recently in the Southwest, among them attempts to explain the lizards' idiosyncratic ocular-sinus blood squirting, the link between their spatial distribution and their diet, and the possibility that smaller clutches of eggs may be a result of the presence of malarial parasites. Radio communication with horned lizards, almost a novelty ten years ago, is now an important component of fieldwork. The technique's efficiency and popularity have resulted in more affordable equipment. The day may come when toe-clipping as a means of identifying individual specimens is no more than a memory.

Ants loom large in the world of horned lizards. Harvester ants have long been a central item in their diet. When fire ants arrived from Brazil and started their march through the Southwest, great numbers of harvester ants were destroyed. Now a new threat has emerged. Argentine ants, a mere two millimeters long, are targeting ants several times their own size as they fan out through the coastal areas of California. Although they arrived in the United States more than a century ago, probably in sugar or coffee sacks, it is only now that their presence is being recognized as a potential danger. Horned lizards will not eat them as a substitute for the

preferred harvesters. But a shortage of customary diet is not the conclusive reason for the reduced population of horned lizards. One analysis of vegetation cover relative to Texas horned lizard distribution indicated that habitat is more a determining factor than availability of food. Although the lizards eagerly tackled nearby anthills, they chose to inhabit dirt roads and even an asphalt airstrip rather than covered ground that might better have concealed them. Such open locations incur risk from human and animal predators.

While squirrels and starlings, along with numerous other species of wildlife, thrive in cities, horned lizards prefer less populated desert and mountain reaches. They are either unable to adapt to a suburban environment or have had no opportunity to try it out. When they are spotted, they are immediately attractive; no one seems to be scared of them: "Because they are so fearsome in appearance, yet quite harmless, desert visitors tend to collect them to show the folks back home." These words, found by chance on a website, reflect a considerably more ominous threat than the presence of natural predators.

The literature on horned lizards has grown since this book was first published. Besides scientific articles and numerous pages on the Internet, I have read lively descriptions in magazines published as geographically far apart as Mexico and Australia. Two fine new books that support and expand our existing knowledge are Wade C. Sherbrooke's *Introduction to Horned Lizards of North America,* published by the University of California Press, Berkeley, in the California Natural History Guide Series, and *Krötenechsen,* by the Swiss author Bertrand Baur with Richard R. Montanucci. Both are liberally illustrated.